CARO IN ROME

INTRODUCTORY ESSAY
BY GIOVANNI CARANDENTE

EDITED BY IAN BARKER

LUND HUMPHRIES
LONDON

CARO

AT THE TRAJAN MARKETS

ROME

First published in Great Britain in 1993 by
Lund Humphries Publishers
Park House
1 Russell Gardens
London NW11 9NN

British Library Cataloguing in Publication Data
A catalogue record for this book is available
from the British Library

ISBN 0 85331 645 7

Produced for the publishers by
John Taylor Book Ventures
Hatfield, Herts

Designed by
Kate Stephens

Printed in Hong Kong by
Colorcraft Ltd

CONTENTS

The thirty-nine sculptures exhibited
at the Trajan Markets are listed on
pages 110 to 116 in chronological order.
Thirty-four of these are illustrated in this
volume and plate numbers are given where
they are referred to in the text.
The list of sculptures and the plates are
cross-referenced. All works referred to
in the text which were not exhibited in
Rome also carry numbers which refer to
the Catalogue Raisonné of sculpture
by Anthony Caro.

THE SCULPTURE OF ANTHONY CARO

BY GIOVANNI CARANDENTE

CARO told me some years ago how excited he was by the archaeological settings in Rome and how much he would like the challenge of exhibiting in one of them. It was an idea he had been nurturing for some time, and was waiting for the right moment. When I wrote to him in early 1991 to say that I thought the Trajan Markets was the most suitable place, he came to Rome to see for himself and was enthusiastic.

'My work', he said, 'has always been to explore, not to reach perfection. This place is a real challenge.' It was a repeat of the situation in 1972 in Florence when Henry Moore's classic modernity was set alongside the humanist landscapes of Giotto and Brunelleschi. Times have changed, and so has art. In 1992 the Trajan Markets, the daily market of ancient Rome, offered the setting for the severe, abstract, bare and uncompromising sculptures of Anthony Caro. 'Sculpture', he told us that day, 'has been very dull since Michelangelo and Bernini. We must give it new life and nourishment, we must give it a chance to signify something new in our lives.' In the same way that Moore created a bond between his work and the fourteenth- and fifteenth-century Florentine landscape, Anthony Caro's exhibition was a unique and unrepeatable experience in this second-century Roman location. The most beautiful of his coloured sculptures of the 1960s were displayed in a magical sequence on the terraces overlooking the Roman Forum. The challenge the sculptor faced in siting both his solid and linear sculptures against the imposing structure of the Roman monument was won handsomely.

There is no doubt that Anthony Caro has decisively changed the course of British sculpture and prepared the ground for a new vision of sculpture from the 1960s onwards. His exploration of this field has been always rigorous and demanding. His ongoing desire 'to push sculpture to its limits' has been widely recognised for, as a young artist mentioned recently, 'He's the catalyst and the man we have to beat. We don't necessarily want to ape his methods or his style, but we have to acknowledge his example through his sculpture, that anything is now possible.'

Anthony Caro was born in New Malden, Surrey on 8 March 1924 into a middle-class Jewish family. His father was a stockbroker and like Caro's mother came from Norwich. Caro had a conventional education but he soon began to show a leaning towards the arts. During his vacations he frequented the studio of the sculptor Charles Wheeler in London.[1]

Like Alexander Calder, Caro went on to study engineering. He entered Christ's College, Cambridge and then, at the end of the war, attended the Regent Street Polytechnic in London. These two periods of education were interrupted by his national service as a Royal Navy pilot. But his passion for sculpture eventually got the better of him, and at the age of twenty-three he was admitted to the Royal Academy Schools. Here the tutors, such as sculptors McWilliam, Hardiman and Maurice Lambert (who later became head of the Sculpture School), favoured the traditional classical approach. While at the Royal Academy Caro met Sheila Girling, whom he married in 1949. They have two children.

The first major shake-up in Caro's academic training came at the age of twenty-six, when he took a position in Henry Moore's studio at Much Hadham in Hertfordshire. He remained under Moore's guidance on and off for three years.

Caro's early works significantly demonstrate the preferences which have always urged him into new areas: besides Moore's influence (which lies rather in the treatment of the material than in formal solutions), other interesting currents revealed themselves very early on, such as Picasso's sculpture and African primitive art.

During this period Moore was working on the solemn and mysterious *Draped Reclining Figure*, for the courtyard of the Time-Life building in Bond Street, London.[2] This work borrowed from his earlier drawings of figures wrapped in blankets sheltering in the Underground during air raids. The rough surfaces of Caro's figurative works – such as *Man Holding His Foot* 1954 (A53),[3] which at its first public appearance at the Institute of Contemporary Arts in London

aroused the interest of David Sylvester, one of Britain's leading art critics; the *Seated Figure* 1955 (A59); and the *Man Taking Off His Shirt* 1955-56 (A69), exhibited at the Venice Biennale of 1958 – echo Moore's combination of concave and convex surfaces and express the same symbiosis of human and natural form which Moore compared to the form of mountains, 'the earth's withered skin'. But while the texture has similarities with the work Moore was doing at the time, the form Caro's figurative sculpture reveals is a more probable parallel with the sculpture of Matisse.

Various references in Caro's work endorse this link. The *Man Taking Off His Shirt*, for example, when viewed from the rear shows the same deep hollow and undulating roughness of the volumes in Matisse's *Torso II*, 1913; Matisse used the same motif of upraised arms for a female figure. Caro's *Portrait of Sheila II*, 1955 has the same firm sense of completion as the oval block of Matisse's *Jeannette V.* Likewise, Caro's *Man Holding His Foot* adopts similar motifs to Matisse[4] though the latter again employs a female figure. While *Cigarette Smoker*, 1957 (A79), betrays Caro's interest in the themes of Picasso, his inquiry into animal forms, as for example in the *Fighting Bull*, 1954 (A56), once again stems from Moore.

It should be noted nevertheless that despite these overlapping influences, Caro's basic sculptural inquiry never really coincides with Moore's. Even during the third year of their time together at Much Hadham, the visions of the two artists were poles apart. Caro would shortly come to realise this, when he decided to veer off in another direction, which will be discussed extensively in this essay.

Caro's figurative repertoire of those few years, which was accompanied by a wealth of intensely modelled drawings using chiaroscuro effects, represented the tension of the body but, unlike Moore, with his use of archetypal models, Caro sought an expressionistic quality of a figure caught in gesture, as found in Matisse's work. Nor was he concerned with the spatial relationships as a dialectic of mass and void. Although he had turned toward a completely abstract form of

sculpture, one senses that he retained an unconscious awareness of the image of Moore's *Reclining Figures:* his abstract sculptures tend toward horizontality, extending themselves across the ground like resting skeletons. Caro, however, has denied this intepretation of his source. The desire to communicate was strong, and before he was thirty Caro began teaching at St Martin's School of Art in London. The majority of talented young British sculptors who have appeared on the scene in the last thirty years gained from Caro's guiding spirit.

The retrospective exhibition of Anthony Caro's work, in the setting of the Roman Forum, is a pertinent reminder of Caro's first solo exhibition held in Italy thirty years ago, in Carlo Cardazza's Galleria del Naviglio, Milan. As Caro recounted later, the pieces were held up at customs at Domodossola, and arrived in Milan three days late. The opening was therefore postponed for a few days, and since there was so little time, the artists Fontana, Crippa and Baj enthusiastically helped him with the installation to ensure that all was ready as soon as possible. The exhibition consisted of twenty figurative sculptures, including those mentioned above as well as some heads. Almost all were modelled in plaster or clay; the catalogue introduction was written by Lawrence Alloway. The exhibition was repeated in London at the Gimpel Fils Gallery, heralding the first impact of Caro's work in the framework of new British sculpture. These early figurative works betrayed certain links with the work of De Kooning and Dubuffet (Caro had seen Dubuffet's exhibition at the ICA in London). There were also traces of Surrealism and Expressionism, undoubtedly derived from Caro's interest in the paintings of Francis Bacon.

In 1959 Caro was awarded the sculpture prize at the Paris Biennale for young artists. The great importance which any striving young artist would attribute to such an accomplishment in an international competition was surpassed by another event: that year in London Caro met the American critic Clement Greenberg, friend and influential supporter of the lesser known artists of the period, such as David Smith and Kenneth Noland. In 1965 Greenberg wrote: '"Breakthrough" is a

much abused word in contemporary art writing, but I don't hesitate to apply it to the sculpture in steel that Anthony Caro, of London, has been doing since 1960. During the 1950s, abstract sculpture seemed to go pretty much where David Smith took it. None of the promise of other sculptors during that time was really fulfilled; some of them produced good things but the good things remained isolated, did not add up to much. Caro is the only sculptor who has definitely emerged from this situation and, in emerging from it, began to change it. He was also the only new sculptor whose sustained quality can bear comparison with Smith's. With him it has become possible at long last to talk of a generation in sculpture that really comes after Smith's. Caro is also the first sculptor to digest Smith's ideas instead of merely borrowing from them.[5]... Caro's sculptures invade space in a quite different way – a way that is as different almost from Smith's as it is from Gonzalez' – and they are integrally abstract.'[6]

Greenberg could make those statements with a certain confidence, as there had been significant developments since his visit to Caro's London studio in 1959. That year Caro went on his first trip to America on a Ford Foundation Grant, where he briefly met both David Smith and Kenneth Noland. On seeing their work he realised he was at a crossroads in his career and felt the need to change course. When Caro returned to London he travelled to Carnac in Morbihan. Here his inspiration was fuelled by the strong, massive presence of the megalithic menhirs in the lonely Breton countryside. He felt the sense of magic and absoluteness emitted by those evocative, aniconic monoliths.

Caro's first abstract sculpture, *Twenty-Four Hours* 1960 (B 819),[7] was executed immediately after his return from America. Paul Moorhouse's introduction for the catalogue of the exhibition of Caro's work held at the Tate Gallery in 1991, *Sculpture towards Architecture*, correctly noted the influence of Kenneth Noland and David Smith in that early abstract constructivist work by Caro. Caro borrowed Noland's primary forms and the concentric circles, and Smith's steel slabs of cut geometric and regular forms. Caro enlivened his work by

accentuating its three-dimensional sense. Of the three shapes which make up *Twenty-Four Hours,* the trapezoid and the circle are vertical, while the square tilts at thirty degrees to the other two forms.

Moreover, contrary to David Smith's pedestal arrangement, Caro set his work on the ground, and continued to do so until the series of *Table Pieces* which he began in 1966. These works adopt a very different concept of 'base' since the table becomes an integral part of the sculpture. Serialisation, which Caro has frequently adopted over the years, was another aspect inspired by discussions with Kenneth Noland. In 1963 Caro made a longer trip to the United States. With the help of Noland, he obtained a teaching post at Bennington College, Vermont, not far from the studio of Noland and Olitski which was also close to Bolton Landing (ninety miles to the north), where David Smith lived, surrounded by a vast wood crowded with sculptures. In the last group of works prior to his death,[8] which happened a few miles from Bennington, Smith began to use a compact, intense application of colour.

As noted by previous writers on Anthony Caro, the sculptor's American phase was clearly crucial for the successive direction of his art. Caro not only gained from the physical distance of his native Britain, detaching himself from the British currents in vogue at that time (largely dominated by the personality of Henry Moore), but also from his realisation of vital reasons for a stylistic shift towards something completely new and original.

The sculptures which Caro created in the early 1960s were the most simple and linear of his entire career. Their poetic simplicity consisted in a sort of 'minimalist' approach to the new problem. Like Noland and Olitski, however, Caro did not become a minimal artist. These works emphasised the distance which he had set between himself and Moore. Even during his stint in Moore's studio, Caro had never pursued archetypal form.

Now with his articulated arrangements of I-shaped girders his objective was to take sculpture towards architecture rather than to

make mysterious three-dimensional symbols, or the 'inexplicable presences' typical of Donald Judd, Carl Andre or Sol LeWitt. The Canadian art critic Terry Fenton wrote that Caro's work from the early 1960s was the distillation of the 'essential elements of a new sculptural language', stripped of all superfluous information. This period in America was so important to Caro's development that he still lives there for a few months each year, and has kept a studio there. His memories of Kenneth Noland and the atmosphere of those years have always remained with him. He first saw Noland's work on his original trip to America, at an exhibition at French & Co., New York. The friendship between the two artists grew as a result. As he related to me in London recently: 'We used to speak for entire nights, about our lives, and our methods of work. We were stimulated by these discussions, we showed each other our work. It was a marvellous period. Noland was sociable and his Shaftsbury studio was frequented by many friends; Frank Stella, Larry Poons, Helen Frankenthaler, Clement Greenberg.'

The first to realise the significance of the new development was Caro himself. In an interview which appeared in the *Gazette* (London) in 1961 following his trip to the United States, Caro declared to Lawrence Alloway in no uncertain terms: 'America was the catalyst for a change in my work. There's a fine-art quality about European art even when it's made from junk.' (Was Caro thinking of Burri's *Sacchi* here?) 'America made me see that there are no barriers and no regulations. Americans simply aren't bound to traditional or conventional solutions in their art or in anything else... There is a tremendous freedom in knowing that your only limitation in a sculpture or painting is whether it's art.'

Midday 1960 (pl. VIII & IX) now in the collection of the Museum of Modern Art, New York, was created a few months later. It was the first work to be intensely coloured, and was defined by William Rubin as the artist's first completely independent work. The dislocation of the three forms has analogies with Moore's composite *Two- and Three-Piece*

Reclining Figures, which were begun in 1959 (but stem from experiences of the 1930s). Perhaps this parallel is just a coincidence, something accidental or even unconscious. This is not to question the completeness of Caro's renewal nor to overlook his indifference towards figurative form during this period. Caro, however, did continue to explore figurative composition through drawings and even through small sculptures and portraits completed during the early 1980s.

He recently stated: 'I am not an iconoclast. I consider sculpture as my subject. My art is like a religion which has nourished my life. All I want to do is to give vitality to the form. I do not intend to break with the past but to stay vital, sculpture needs to be re-invented again and again.'[9] Works which attempt a complete renewal sometimes betray links, albeit unconscious, with existing forms, near or far, and it is not sacrilege to point them out. This is borne out by the appeal of *Midday* which I believe lies in the complete freedom with which Caro uses a Constructivist syntax to bring together rigidly industrial elements. They are cut to meet the requirements of his sculpture and are assembled in a purely architectural order. As with *Twenty-Four Hours* before it, the elements of *Midday* have different inclinations. The large base, which is the fourth component of the work, lends unity to the other three.

Caro himself stated that through this revolutionary sculptural approach he tried 'to eliminate references and make truly abstract sculpture, composing the parts of the pieces like notes in music. Just as a succession of these make up a melody or a sonata, so I take anonymous units and try to make them cohere in an open way into a sculptural whole. Like music, I would like my sculpture to be the expression of feeling in terms of the material, and like music, I don't want the entirety of the experience to be given all at once.'

The most important statement emerging from *Midday* and the works that followed is the sculptor's intention to provoke a complete rethink of the concept of sculpture. One of the most radical transfor-

mations was allowing the work to expand parallel to the ground instead of rising from it, as had been the form at least until David Smith's sculpture. Caro's sculpture occupied space in a new way, and its three-dimensionality obliged the viewer to circle it. The viewing point for the sculpture becomes multiple and the sculpture no longer has one focus. These concepts would remain for some time. This period also saw an overhaul of methods used in the work place as well as teaching methods. Modelling in clay and plaster was replaced by construction with industrial steel elements.

In the summer of 1960 the artist equipped himself with large steel girders and other shapes of large dimensions (following the death of David Smith, he salvaged some of the remaining material from Bolton Landing). Caro employed these new materials in a group of sculptures (some of which he destroyed, though they are documented): *The Horse* 1961 (pl. XVI), which began with the neutral title of *Sculpture I,* retains great evocative strength, and *Sculpture Seven* 1961 (pl. X & XI), from the summer of that year, was the first work to be painted in more than one colour, with green, brown and blue. The sculptor used neither maquettes nor preparatory drawings; his method of working was direct, face to face with the brute reality of the material. The sections were riveted and welded with an engineer's accuracy. During 1962, for a brief period, Caro began incorporating aluminium sheets and tubing. One of his most suggestive creations of this period is *Early One Morning* 1962 (pl. XXIII & XXIV), an aluminium and steel composition painted brilliant red. It was exhibited at the Tate Gallery three years later in the exhibition 'British Sculpture in the Sixties', organised by the Contemporary Art Society, who then purchased the work and donated it to the Tate. While *Sculpture Seven* still retains echoes of the horizontal pictorial compositions of Kenneth Noland, other cogent works of this decade such as *Sculpture Two* 1962 (pl. XII, XIII & XV), painted green, *First National* 1964 (B 835), in three distinct sections painted green and yellow, *Titan* 1964 (B 840), painted blue, *Shaftsbury* 1965 (pl, XXXVII & XXXVIII), painted purple, and *Deep Body Blue* 1967 (B 908), are among

the dozen or so superb linear pieces of Caro's early abstract repertoire.

The work significantly entitled *Homage to David Smith* 1966 (B 886), in steel painted orange, executed the year after Smith's death, is emblematic of the decade in which, as Greenberg predicted, Caro was recognised as the most worthy heir to Smith, one of the two great figures of twentieth-century American sculpture. That eminence is shared, in my opinion, by David Smith and Alexander Calder (not only for Calder's joyful works and *Mobiles*, but also his monumental *Stabiles*). Alongside the linear sculptures, of which some (*Titan, Flats* (B 836) and to some extent also *First National*) expressed a completely new labyrinthine arrangement in zigzags, Caro began another important group of more articulated and increasingly complex works. In these he sometimes inserted tubes or large metal mesh elements and even Suprematist symbols, such as squares or crosses (quoting from Malevich perhaps) as in *Early One Morning*.[10] These works provide clear evidence of the extent of Caro's attempt to imbue his abstract expression with the historic sources of abstract art. This had numerous variants, ranging from the geometric compositions of late Kandinsky, the *gouaches découpées* of Matisse, the Constructivism of Tatlin and Pevsner, the Neo-Plasticism of Mondrian (detectable in Caro's work) to the Cubist *collage* and, lastly, to a synthesis of the plastic arts centralised on architecture so typical of the Swiss sculptor Max Bill.

Early One Morning 1962 and *Prairie* 1967 (B 911) are among the most important works of this group, the first for the joyful aerial combination of the structures, the second for the serene order given to the horizontal development in all directions.

Other works with a significant architectural quality include *Month of May* 1963 (pl. XIV), painted magenta, orange and green, *Span* 1966 (pl. XVII & XVIII), painted red, *The Window* 1966-67 (B 903), painted two tones of green, and *Sun Feast* 1969-70 (pl. VI & VII) painted golden-yellow. In some, such as *Span* and *The Window*, even the title suggests the specific direction of the work. *Orangerie* 1969 (pl. XIX & XX) takes another path. The elegant arrangement of the shapes brings to mind

the type of assemblages which David Smith had devised in Italy, using scrap iron, trimming from steel sheets and I-beams which he procured from the Italsider steelworks at Voltri. *Voltri IV* (June 1962) gives a direct clue to this plausible parallel.

Orangerie is one of the most important works of modern sculpture, and a singular cogent example of autonomous invention and graceful imagination . Its most striking aspect is the merger of Constructivist rigour with the harmony of composition.

After some months spent mainly in the United States, Caro returned to London to a growing recognition amongst contemporary European sculptors. A series of exhibitions of his work were shown in London at the Tate, Whitechapel and Hayward galleries, as well as in private galleries.

Caro's European dealer to begin with was Kasmin, to be succeeded later by Annely Juda Fine Art; André Emmerich was his New York agent, and still is today. The exhibitions travelled across Europe, to Zurich, Otterlo, Arnheim, Sonsbeck and Venice. Caro was represented at the British Pavilion in the 33rd Venice Biennale in 1966, in an exhibition of five young British artists. He won the Bright Foundation award reserved for emerging artists (an admirable tradition which unfortunately was discontinued after 1968).[11]

The year 1966 saw the beginning of Caro's newest series, which the artist called *Table Pieces,* a term reminiscent of the eighteenth-century *Conversation Pieces.* After discussions with Michael Fried in the summer of 1966, Caro conceived the idea of small-scale sculptures designed to be arranged on tables – sometimes parallelepiped – to offer an authentic base as part of the piece; a few rested on a metal pedestal. Initially the *Table Pieces* incorporated *objets trouvés* or other manufactured components which would sometimes jut out from the plane of the table. These first pieces always had polished surfaces, varnished with shiny enamel. The series was labelled with Roman numerals, but sometimes Caro added an explanatory subtitle. Using this method Caro has completed at least eight hundred splendid small sculptures.

These autonomous works are not merely maquettes for larger works but unique spatial ideas (as were the wire sculptures of Calder), surprisingly rich in inspiration and humour. In these works the artist employs the entire vocabulary of his structural inventions: the industrial girders (reduced in thickness), curves, rings, profiles, narrow tubing, disks, rectangles, half-moons, fragments of mesh and other scrap from the steel works, in an amazing kaleidoscope of inventions which alone would be enough to ensure the artist's fame.

After four years creating new and original formulae, Caro reached his 106th composition, *Table Piece CII* 1970 (B 106). This particular work shows links with inventions that David Smith had devised at Voltri in 1962 in a series of three *ante litteram* table pieces: *Voltri XVI*, *Voltri XVIII* and *Voltri XIX*. In the latter, the pieces that move off the plane are some scrap metal, a pair of pincers, weakened by heating and folded, and a pincer blade. In *Table Piece CII* Caro uses Smith's idea of abandoned objects on a plane, but with objects invented by the artist himself, however, and not scrap. The link is therefore only in the method of work, and not in the result achieved.

In his prolific sequence of *Table Pieces*, Caro progressively distances himself from this analogy with Smith. He draws on an ever-increasing variety of themes, enriched with new suggestions, the most stimulating of which are the series of *Source Sculptures*, which will be discussed later.

The extraordinarily varied *Table Pieces* are a major chapter in Caro's repertoire, but they also provide a concise display of his sculptural inventions, and betray the stylistic motivation behind them. In the first sculptures of the 1960s Caro created sculpture which spread horizontally, without the need for a base, although they always developed on a plane. The sculptures of lesser proportions again make use of this plane, in this case that of the table, the most common and domestic piece of furniture. From 1966 to 1985 other groups followed, and the titles of these provide further clues for identification – *Box Pieces*, *Ring Pieces*, *Writing Pieces* and *Wall*

Pieces, each title indicating the type and morphology of the work in question.

Dieter Blume, the German author of the *Catalogue Raisonné* compromising ten volumes covering Anthony Caro's oeuvre (which by 1993 numbered over 2500 works), meticulously stated that the term 'piece' if used alone can indicate both a standing sculpture or a low table piece. To back up his claim he adds that the jumps in the sequence of Roman numerals are due to Caro's self-critical working method, to the destruction of a work or the reutilisation of parts in a successive sculpture.

The sculpture *Table Piece LXXXVIII* 1969 (pl.XLIII) bears the subtitle *Deluge.* Painted in opaque yellow, this work launches the series of *Source Sculptures.* As identified by John Russell (1970), the title (and therefore the composition) was inspired by Leonardo's *Deluge* drawings which Caro had seen in an exhibition of the Royal Collection at the Queen's Gallery, Buckingham Palace. The sense of movement was an intrinsic feature of Leonardo's drawings, likewise his convulsive natural, animal or plant forms, and the interaction of motifs, poses and movements. In his study for the *St Anne* cartoon in the National Gallery and in the Windsor series of drawings of water eddies, as well as in the *Deluges,* the force lines have a masterly expressiveness. These offered a suitable stimulus for the complex interlacing group of curving lines in this sculpture of Caro. At the time the inspiration was not explicit but only hinted at in the title. However, in successive works the influence was openly declared.

Table Piece Y-49 'After Picasso' (pl.XXX) states it clearly and supplies a means of interpretation, as Picasso himself had done with *Las Meninas,* offering an alternative pictorial syntax while the content remains similar. This is the approach Caro himself adopts. The reference is to Picasso's Cubist painting *Bread and Plate of Fruit on Table* 1909 in the Kunstmuseum, Basle. The transcription of the figurative elements is literal, although in Caro's work they take on abstract forms and have become three-dimensional. Picasso's overturned table with its echoes

of Byzantine perspective is reworked to be the closest element of reality, while the folds of Picasso's curtain become, on the viewer's left, two independent modelled forms. It seems appropriate that the linear Cubist perspective is transformed into geometric symbols placed in an aerial perspective.

Even more convincing is the comparison between the model and the source sculpture of *Table Piece Y-92 'Triumph of Caesar'* 1987 (pl.XXXV). Here the angular table plan accentuates the sculptural values of the composition. Caro was clearly struck by the masterly sense of perspective of the nine famous canvases which Mantegna painted for the Gonzaga family, now in the Royal Collection at Hampton Court Palace. Caro chose *The Trophy Bearers,* the third and most sculptural of the group. He translated the upper section, the most dynamic and eventful with the trophies carried on pikes, with armour, shields, headpieces, emblems and vases brimming with coins. On the right he included the trumpets from the next work in the group, like so many lances from one of Paolo Uccello's *Battles.*

Mantegna's forms are rendered abstract and transformed by Caro into pure sculptural values, retaining the original rhythm, solidity and tympanum arrangement. *The Moroccans* 1984-87 (pl. XLVI) is unusual for the materials employed: stoneware and terracotta with the hidden supporting structure made from stainless steel. The title and composition derive from Matisse's painting of 1916 of the same name in the New York Museum of Modern Art. The painting is divided into three distinct areas, separated by the dense black of the background, and offers a condensation of Matisse's memories of Tangiers, the city houses, the Mediterranean flora and the people seen from the terrace of the little Casbah cafe. In one of his outstanding writings on the work of Matisse, Alfred Barr wrote that the three sections are like the three movements of a symphony. Caro also divided his work into three parts separated by horizontal planes. The upper part is clearly inspired by the Matisse-style architecture, while the middle section seems to invoke the palms and tangerines in the lower left of Matisse's painting.

The rest simply derives from the 'architectural' requirements of the sculpture, and is the fruit of a free variation on the theme.

The series of *Source Sculptures,* including studies after Rembrandt, Rubens and Manet, reaches the most ambitious treatment in *After Olympia* 1986-87 (pl. XLIX, L & LI); this monumental work, which was finished at the same time as *The Moroccans,* will be discussed later.

From the works which we have examined up to this point, it is clear that the art of Anthony Caro is not of a uniform single direction, nor intends to be. In the 1960s the artist's foremost concern was to establish a new sculptural language with linear and architectural elements, and explore the use of modern polychromy, with the self-professed aim of pushing sculpture towards drawing, painting and architecture. In the 1970s, his work moved decisively toward more autonomous and monumental structures, using harsher materials and an even more independent repertoire of forms.

At the beginning of the 1970s a radical shift occurred which distanced Caro even further from David Smith's motifs, bringing his work alongside that of other artists in the contemporary international art scene. Richard Serra is one of these artists, who, together with Mark di Suvero, tended during this period toward an elementary form of sculpture that was dramatically imposing and solid in its structural severity. In 1969, while critic for the *New York Times,* Hilton Kramer had voiced some reservations regarding the originality of the sculptures created by Anthony Caro in the 1960s; he then considered Caro's contribution to be largely a question of projecting received ideas (and principally those of David Smith) to a new level of sophistication and refinement. However, by the spring of 1970, coinciding with the exhibition of such works as *Orangerie, Sun Feast* and *Deep North* 1969-70 (pl. XXXVIII) in the André Emmerich Gallery, New York, Kramer decisively stated that now this British artist was, without rival, the major sculptor of his generation. He wrote of Caro: 'He is unquestionably the most important sculptor to have come out of England since Henry Moore ... One has the impression of an artist who, having

totally mastered a new and difficult area of sculpture syntax, is now permitting himself a freer margin of lyric improvisation.'[12] *Ordnance* (pl. XLIV) and *End Game* (pl. XXVI & XXVII) are both from 1971 (although the second was finished much later, in 1974). While *Deep North*, a little earlier, had marked the close of the series of painted sculptures, *Ordnance* and *End Game* opened a new category of works, increasingly bleak and severe.

Ordnance, with its austere, regimented repetition of geometric elements, employs spatial articulation and the compositional order of *Prairie,* though realised in a different way. *End Game* employs a similar ordering of effects. The sculpture becomes abstractly enigmatic, an end in itself. The same thing happened to the work of Barbara Hepworth, but now the spirit and the language was of changed times. The 1970s brought no mystery or inexpressible elements which the artist's inventiveness could grasp. And yet there is something inexpressible in *Ordnance,* in the repetition of the triangles, in the horizontal progression of the L- and I-shaped beams, in the severity of the more openly architectural but transparent conception. These two sculptures and those that followed are of rusted steel. The rust has been 'frozen' by a coat of varnish.

Caro's calendar for 1972 was rich in Italian appointments. In the summer he exhibited at the Venice Biennale. In the autumn he returned to Milan, where Beatrice Monti offered to stage an exhibition of his work in her Galleria dell'Ariete, and had suggested Caro create the works in Italy.

Before fulfilling this commitment, Caro decided to travel with Piero Dorazio to visit Italy's artistic cities. On their arrival in Florence the two travellers parted company and Caro continued his journey alone. He remained in Florence for over a week, gathering his impressions in an article entitled 'Some thoughts after visiting Florence'. This piece appeared in the Swiss magazine *Art International* in May 1974.

Caro recently stated: 'From the Renaissance I didn't find the sculptors who decorated the architecture of great interest. But

Donatello is another thing. In his reliefs, balustrades, steps, arches, he constantly gives the idea of sculpted architecture. Also the *Gattamelata* of Padua is enclosed in its diagonals. In the *Judith,* I found two frontal view points, that of the head of the Judith which forms a square with the arm and the sword and the other at forty-five degrees, of the legs of Holofernes. I found that it is an extraordinary sculptural idea. I have always loved Donatello, since I was a student. At twenty-four years old, when I was still at the Academy, I made an equestrian sculpture thinking of *Gattamelata*.[13] Donatello's form is hidden, controlled and contained. His strength is evident but it is never asserted. In Roman sculpture, instead, the form explodes. When last year I went to Rome to see the Trajan Markets, I didn't miss paying a visit to Michelangelo. I realised that Michaelangelo had painted and sculpted so many muscles because he had the force and energy of Rome to inspire him.'

On his return to Milan, Caro was sent by Peppino Agrati to the Rigamonti steelworks in Veduggio, Brianza. What took place was reminiscent of David Smith's experience at the Voltri steelworks ten years earlier; a meeting of two worlds, Anglo-Saxon and Latin, with the language barrier allowing little dialogue, and a hard, relentless task of immense dimensions. Assisted by James Wolfe and the Rigamonti workers, in two weeks Caro produced the Veduggio series of fourteen sculptures, keeping up the same rhythm of daily production as Smith had done at Voltri, as described in the frequently published letter to David Sylvester, then critic of *The Observer,* London.[14]

Caro was using entirely new materials: huge scraps of steel with blunted edges in the form of sheets and girders, most of which were cut irregularly. In the following spring and autumn he returned to Veduggio to refine some parts of the sculptures and finally to transport some of the materials back to London. The immense metal pieces which appear in successive works, realised in London, *India* 1976 (B 1138), *Panama* 1976-80 (B 1140) and *Cliff Song* 1976 (B 1142), are among those brought from Veduggio.

This series of works signalled a further shift in the language Caro

had adopted up to now. The sculptures became more open, inserted in space with a new monumental sense, a new sense of volume, and an unprecedented tendency toward the vertical. The ideal of a more articulated steel sculpture, which goes back beyond Smith to the prototypes of Gonzalez, is replaced by Caro with a more spontaneous attitude to the materials. The cuts and the perspectives of the steel sheets are irregular and the architectural sense no longer comes from the geometric linearity of the solutions, but from the power of the volumes and masses, squared, strong and intersecting at right angles, as in the dramatic *Veduggio Sound* 1972-73 (pl. XXIX), of the Kunsthaus in Zurich, in which the relationship between the parts has a musical rhythm.

The vigorous power of the Veduggio is developed further in the series of works executed in Canada in 1974. This group comprises thirty-seven large sculptures (Caro is a prolific artist, almost obsessed by the constant drive to create more and more works in parallel). That summer Caro had at his disposal the huge steelworks of the York Steel Construction outside Toronto, with huge and heavy masses of steel, fixed and mobile cranes and all the other technical aids of the factory.

The result was the *Flats Series* (B 1068-1108, B 1111-1113) which, despite their name, were among the most solid and powerful sculptures he created up to the end of the 1970s. The change which had begun at the start of the decade became more radical. No more the simple forms and the aerial arrangement of the early 1960s, nor the application of colour. Ten years earlier the sculptor had been supplied with a stock of industrial materials. Now he was able to delve in the fire of the foundry for the roughest, most imposing, and most irregular elements, to assemble them in improvised combinations creating astonishing lines of force. During this period the dynamics of Caro's sculptures approached the energetic minimalism of Richard Serra, but again the parallel is merely accidental. The work of the two sculptors follows diverse paths. The dialogue which Serra established between his masses and the precarious balance of their positions is quite unlike Caro's severe Constructivist ideas with their underlying poetry.

In Caro's work, the steel maintains the expressive marks of the rolling-mill and furnace, the crude roughness of the primary material of the ironworks. *Toronto Flats* 1974 (pl. XLVIII) is a cogent example, with its rough handcrafted seams, which seem minuscule compared to the grandness of the material. The sculpture is composed of matter and work, a structure dominating space, presence. It represents the statement of a vital experience which, although related to reality, offers existential aspects.[15]

Durham Purse 1973-74 (pl. XXXIV), *Roman* 1970-76 (pl. XXXIII) and *Midnight Gap* 1976-78 (pl. XXII) all show a return to horizontal development. The alteration of the motifs also reflected the sculptor's customary orthodox seriality, and confirms Caro's attitude to sculpture as an open-ended means of investigation in three dimensions. Near the city of Durham in northern England, famous for its castle and Norman cathedral, a steelworks produced a pliable type of steel which facilitated the curved forms of the piece, and suggested its title, *Durham Purse*. David Smith achieved a similar, unusual effect with the vertical extension using a crumpled sheet of iron in *Voltri VIII* 1962. *Durham Purse* is part of a series of ten works in which the material is folded to the requirements of the varied assemblage of large sheets combined with smaller pieces of scrap from the steelworks.

In a lecture given at Oxford in 1979 on the historical antecedents of contemporary sculpture, Anthony Caro stated: 'A great many materials can be used in a collage way. And despite its history, collage need not necessarily be used in a cubist way.' Prior to this he stated that despite the contemporary interest of sculptors in creating monolithic works, it would have been foolish to discard the possibilities that collage had opened (during the avant-garde) and has continued to open. 'Collage, the sticking of pieces together, has taken sculptors' emphasis right out of the area of craft and by the directness of fabrication, has allowed sculptors to address their attention to trying to be more expressive.'

The idea for *Roman* 1970-76 clearly takes its cue from the harmony

of the ancient architecture of Rome. The juxtaposition of arches and right angles, and the vigour and simplicity of the lines, has influenced this assemblage of solid, rational and solemn structures. A warm glaze seals the rusty, dark surface. A decade after, as will be discussed later, Caro returned to the theme of Rome, this time steeped in memories.

In *Midnight Gap* a blue-green steel sheet is enclosed in a tangle of metal made largely of *objets trouvés,* a motif which occurs with increasing regularity after this work.

In Lake Emma, in western Canada, in an obscure location in the province of Saskatchewan, two hundred miles north of Saskatoon, a workshop was established where thirty artists gathered for two months each summer. Since his period at St Martin's in London, Caro continued to frequent workshops with young artists, sharing their work and exchanging ideas. Above all he valued the constructive contact with younger artists. Other British sculptors such as Tim Scott, Peter Hide and John Gibbons have often participated in these workshops. Despite Caro's greater experience, in these settings he adopts an attitude which places him as an equal of those taking part. Since 1982 Caro and other British, American and Canadian artists have directed the Triangle workshop at Pine Plains, New York.

In the twenty works in the Emma group, Caro returned to filiform designs in space, a form he had experimented with in previous works, such as *Deluge.* This revival was dictated by the lack of availability of resources in that particular area.

The pieces are reminiscent of Picasso's wire constructions of 1929, which were made with the technical assistance of Julio Gonzalez and preceded by numerous drawings from Dinard's *Carnet,* no.1044, in July 1928.[16] In this new group of works Caro clearly intended to combine his new light and linear forms, utilising the most appropriate material. *After Emma* 1977-82 (B 1606) concludes the series. Begun in 1977, along with others in this group, the piece was completed only in 1982. This structure has parallels with the project for the Library of Los Angeles which Caro had conceived the year

before, in which the graphic arrangement in space is accompanied by a more marked architectural direction.

The 1980s saw the confirmation and accentuation of these developments. In the last decade, Anthony Caro's predominant interest has been to pursue architecturally-related sculpture. The artist's experience has been enriched with the use of previously untried materials: lead, silver, paper (in some unusual reliefs),[17] brass and bronze. The artist had always previously rejected bronze, as the process of preparing the casts prevented the immediacy of the work. So he devised a system for welding together precast forms. *Rhenish Quarter* 1986-87 (pl. XLV) is constructed in this way using both brass and bronze. It belongs to a series of recent pieces that coincide with the ongoing work of one of today's most gifted young sculptors, Tony Cragg, who has clearly learnt from Caro.

The celebrated British architect Richard Rogers was an obvious choice to introduce an exhibition of the new aspects of Anthony Caro's art in 1989. The friendship between Caro and Rogers began in 1957, when they were introduced by Tim Scott. At this time, Rogers was a student at the Architectural Association while Caro taught at St Martin's nearby.

Rogers recalls that 'This was the beginning of a great period for British sculpture: King, Tucker, Turnbull, Scott, Paolozzi, promoted by Bryan Robertson at the Whitechapel. Tim and I attended some of Tony's classes but it was not until I came back from America, some six years later, that I began to see links between Tony and those architects that were influencing me on the West Coast such as Schindler, Soriano, Eames and Craig Elwood who were building simple steel-framed structures trying to escape from the rigid classicism of Mies van der Rohe and his followers, and the organic romanticism of Frank Lloyd Wright.

'The dynamic nature of Tony's brightly coloured, bolted and welded steel sculpture of that time excited me greatly and fitted in with some of my other preoccupations for Cubist, Constructivist and Futurist

artists. Tony shared with these sculptors and painters a commitment to the rich potential of modern industrial society as well as their aesthetic interests in the play of light and shadow, in construction and in movement.

'Today I can see a parallel between our Lloyd's of London Building, 1980-86, and Tony's work of the same period, the more rounded, less abstract form of his *Final Series* (B 1917-1921). In both there is a richer play of void against solid, of frame against infill, of concave against convex, of straight against curved... We now search for forms more varied and articulated, where the eye is led across and through layers so that there is a continuous dialogue between mass and transparency.'

Rogers thus presented an accurate description of the new direction that Caro's work had assumed. The fullness of the forms, the alternation of the mass and void, the skilfully treated surfaces, rendered smooth with either varnish or wax *Night and Dreams* 1990-91 (pl. XLI), and above all the development of the preceding abstract simplicity into more complex and intriguing images had made Caro's work even more vital.

Child's Tower Room 1983-84 (pl. XLVII) was conceived as an environmental installation commissioned by the Arts Council. For the same project, in which four artists were involved, Howard Hodgkin painted a room. The dimensions were in a certain sense prescribed since the work was to be displayed in a limited space at Liberty's in London. When the installation was exhibited at Southampton, as elsewhere, children were able to climb into it. In this way Caro's idea of merging sculpture and architecture, form and space, to create what he dubbed *Sculpitecture*, found a highly logical outlet.

After the *Child's Tower Room,* Caro decided to go a step further. In October 1991 his monumental *Tower of Discovery,* in painted steel, measuring seven metres high, occupied the entire central octagon of the Tate Gallery, this time allowing access to adults, who were able to observe it from all sides and all levels.

'I wanted to expand the limits of sculpture, creating something on

an architectural scale which could vaguely be indicated as sculpture. Architects today do not dirty their hands enough. My work in the 1970s was pure because then the times were pure. Now I find myself in the position in which I want it to be more cogent and more complex.'

With his pragmatic approach the artist gives an honest explanation of his intentions. To quote Rogers again, his recent works offer a 'mirage of usability, transcend need and function and become authentic sculptural works on a large scale'.

The architectural aspect is maintained even on a smaller scale and includes the revival of earlier features. *Odalisque* 1983-84 (pl. XXXIX) and *The Soldier's Tale* 1983 (pl. XL) have huge concave forms which alternate with rigid ones, while *Sun Gate* 1986-88 (pl. XLII), *Medusa* 1989 (B 2068) and *North of Rome* 1989 (pl. IV & V) alternate architectural forms with more graphic motifs.

The piece *North of Rome* has an interesting story behind it. Caro was in Edmonton in Canada when he executed this work. In this cold and remote area Caro thought about the ancient majesty of the architecture of Rome, with its columns and the cupola of the Pantheon. The geographical distance seemed to kindle a sort of nostalgia in him, or, to put it in his own terms, the vision was like a buoy, something to hang on to in the turbulent ocean of his myriad sculptural inventions.

Caro has travelled all over the world, witnessing all its civilisations – from the Aztec and North American Indian cultures, to those of the Australian Aborigines and India. He has visited New Zealand and Japan, has held workshops in Holland, Germany, Barcelona and, as already mentioned, in Italy and Canada. As a sculptor he had yet to make that 'total' voyage into the origins of Western civilisation, so in 1985 he left for Greece. This living scenario of the myths and history of the classical world fired Caro's imagination. He was struck by the rhythm created by sculpture and architecture in sites such as Delphi, the Parthenon, Mycenae and Olympia.

Their impact on him was profound: 'What struck me most was the

pediments of the Temple of Zeus at Olympia and also those of the temple at Aegina, which I saw at the museum in Munich afterwards.

'When I look at the sculptures contained in the shape of a pediment, I do not think only of the sculpture in itself but also of its compression in the architectural structure. In Greek sculpture I don't like the perfection of Praxiteles, I prefer the exuberance of Pergamum, which is like Rubens. I realised that I had to make a classic form in a modern language.' In 1987 he translated this experience into *After Olympia*, in which the 'after' is simply a temporal reference.

After Olympia is one of the most monumental works that a contemporary sculptor has accomplished and not simply because of its ambitious dimensions with a length of about twenty-four metres. Caro was only able to make this piece after his studio had been cleared of all other works.

The new piece was created in separate parts and is made up of four sections united by a long base, which provides the same coordinating function as the architrave in antique architecture. The inspiration originates from the west pediment of the Temple of Zeus, a work by the sculptor who Ranuccio Bianchi Bandinelli named the 'Master of Olympia',[18] now in the Alte Pinakothek, Munich.

The pediment represents the battle of the Centaurs and the Lapiths (a theme later adopted by Michelangelo). The plinth on which Caro's entire composition extends has a slight entasis. Corresponding to the east pediment, the sculptures are separated from one another, arranged and 'compressed' according to the triangle of the pediment. Other parallels with the original lie in the rhythm of the forms and in the distinct unity of the blocks.

The rigour and freedom of disposition of the figures of the *Apollo* and the *Centaur Abducting Deidamia*, to cite just two details of the west pediment (not to mention the incredible modernity of the *Groom Holding His Toe* on the east pediment) would not even have been understood in Canova's time, enclosed as they are in their paradigmatic truth. Only a sculptor free of figurative restrictions and

unaffected by mannered Neo-Hellenism would have the courage to repeat these sculptural forms, but not the images, and with a freedom which only twentieth-century art allows.

Caro took up the challenge boldly. His interpretation of this antique legacy is a significant contribution to twentieth-century art. Exhibited in the Main Hall of the Trajan Markets in Rome, *After Olympia* represented the climax of the *Caro a Roma* exhibition. As in Hadrian's times, Caro was able twenty centuries later to engage, with his new sculptural language, the Greek ideals of beauty and perfection and the solidity of Imperial architecture. This huge contemporary work of sculpture was perhaps in its most perfect setting under the majestic Roman arcades of the Trajan Markets.

1

Wheeler was later President of the Royal Academy from 1956 to 1966.

2

Moore was meanwhile working on the abstract bas-relief which decorates the façade of the same building in Bond Street.

3

Ten volumes of the *Catalogue Raisonné* by Dieter Blume have been published since 1981 (distributed by Lund Humphries, London). These document Caro's sculpture from his student work in 1942 (Vol IV) to date. For identification purposes Caro's figurative sculptures Vol. IV and Vol. VIII are numbered after the prefix 'A'. All other works do not have a prefix before their number as published but are generally referred to with the prefix 'B' (for Blume) for identification purposes. A General Index was published to accompany the volumes in 1991. Several lectures by Caro and important articles published on his sculpture together with his biographical details are also contained in these volumes.

4

Caro felt spiritually close to Matisse, although he acknowledged the influence only in his later works, such as *Early One Morning*, 1962. *Garland*, 1970 (B 936) and *The Moroccans*, 1984-87.

5

As unfortunately had happened with many cele-brated European sculptors of the 1960s.

6

American art critics had failed to note, however, the importance which the extraordinary work of Eduardo Chillida has assumed in Europe.

7

The titles of Caro's work sometimes have an enig-matic meaning, becoming more complex according to how random or independent the title is from the work's origin. The titles rarely reflect the visual elements, nor do they ever allude to the structures of the work, which remain abstract and silent. Sometimes they contain a time of day, a season, person, colour or, as in *After Picasso*, a source. 'I try not to be sententious with the titles of my work', he replied recently to my question as to what signifi-cance he attributes to the titles, 'sometimes they are nothing more than the brand of colours which I use (Pompadour pink or Prairie gold). At the beginning I simply wanted to number the sculptures. At times, however, I like concealing the source of the inspi-ration (*Chorale*, 1975-76 (B1148) for example, was suggested to me by the Luca della Robbia 'Cantori'). Sometimes I intended my titles to be explicit, as in *Medusa*, and at other times almost mechanical.'

8

David Smith died in a tragic car accident on 23 May 1965.

9

In his London studio, February 1992.

10

With regard to this work Caro stated, 'Even though it was a work of Alexander Calder which gave me the initial suggestion, my main source was painting rather than sculpture.'

11

Caro's exhibitions in Italy were more frequent from this point. In the following Biennale, 1968, he was included in the exhibition *Indirizzi Della Ricerca Contemporanea*, in the Central Pavilion; and in the 1972 Biennale he participated in an exhibition of open-air sculpture in the city. *Midday* was installed in Campo Santa Maria del Giglio.

12

The two quotes by Hilton Kramer (now Editor of *The New Criterion*) appeared in the *New York Times*, the first in October 1968, and the second in May 1970. They both appear in the most accurate chronology on Caro, compiled by Elinor L. Woran in William Rubin's volume, *Anthony Caro*, pub-lished in 1975 by the Museum of Modern Art and distributed by the New York Graphic Society.

13

cf. Dieter Blume, 'Anthony Caro', *Catalogue Raisonné*, cit., vol. IV, A 15 and A 16.

14

Reproduced in full manuscript form in G.Carandente, *David Smith*, 1964, cit.

15

At the time those new works had been acknowledged in Italy. At the end of 1974 and continuing until the following January, the Galleria dell'Ariete of Milan exhibited seven *Table Pieces*. Contemporary to this, the first large retrospective of the artist was held at the Museum of Modern Art in New York, subsequently touring to other American cities.

16

cf. W.Spies, *Les Sculptures de Picasso*, La Guilde du Livre, Lausanne, 1971, pp.68-71. Dinard's *Carnet* is published in full in the exhibition catalogue *Picasso, Opere dal 1895 al 1971, dalla Collezione Marina Picasso*, Venice, Palazzo Grassi, Florence, Sansoni, 1981, pp. 295-309.

17

In 1981 the American graphic expert Ken Tyler invited Caro to do some graphic works, utilising the technical means of his workshop. Instead of engravings or lithographs, Caro created reliefs in paper, using the medium with great effectiveness to produce 123 one-off works. Some are reproduced in *Aspects of Anthony Caro*, the catalogue of the exhibition mounted in 1989 at the Annely Juda Fine Art Gallery, London. Caro realised a second series of paper works in Japan in 1990 in Nagatani's workshop in Obama. This second group made use of Japanese materials and a variety of colours. (See the catalogue, *The Obama Series* with an introduction by Ian Barker, published for Caro's exhibition in Tokyo, 1992, Fuji Television Gallery).

18

The great Italian archaeologist Ranuccio Bianchi Bandinelli in his masterly essay *Storicita dell'Arte Classica*, Florence, Electra, 1950, p. 25, wrote: 'Sometimes a century strives to bring forth a Master who, in one word, utters what generations have laboriously stammered. Surpassing Ionic, Doric and Attic predecessors, but composing their research in a new language, the Master of the pediments of Olympia soon revealed himself with works which only now are universally recognised.'

AT THE TRAJAN MARKETS

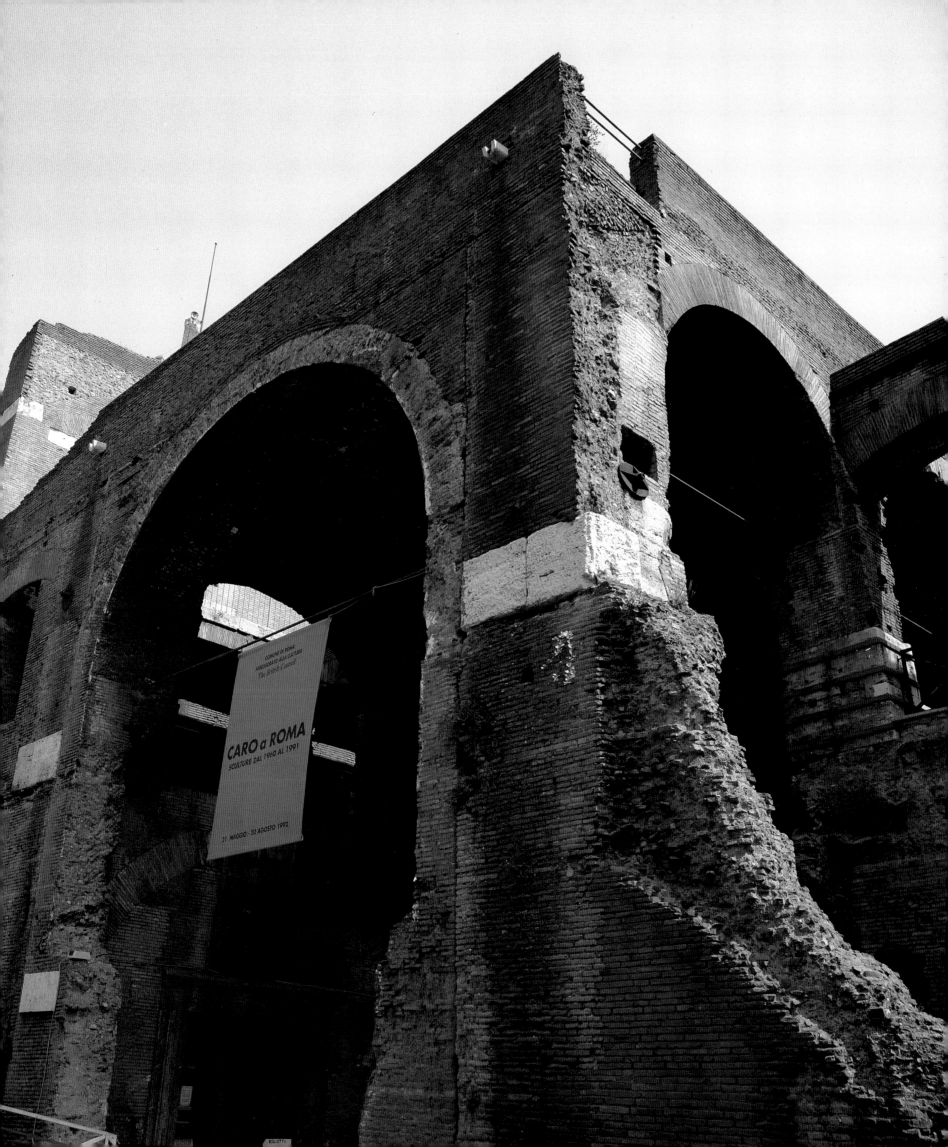

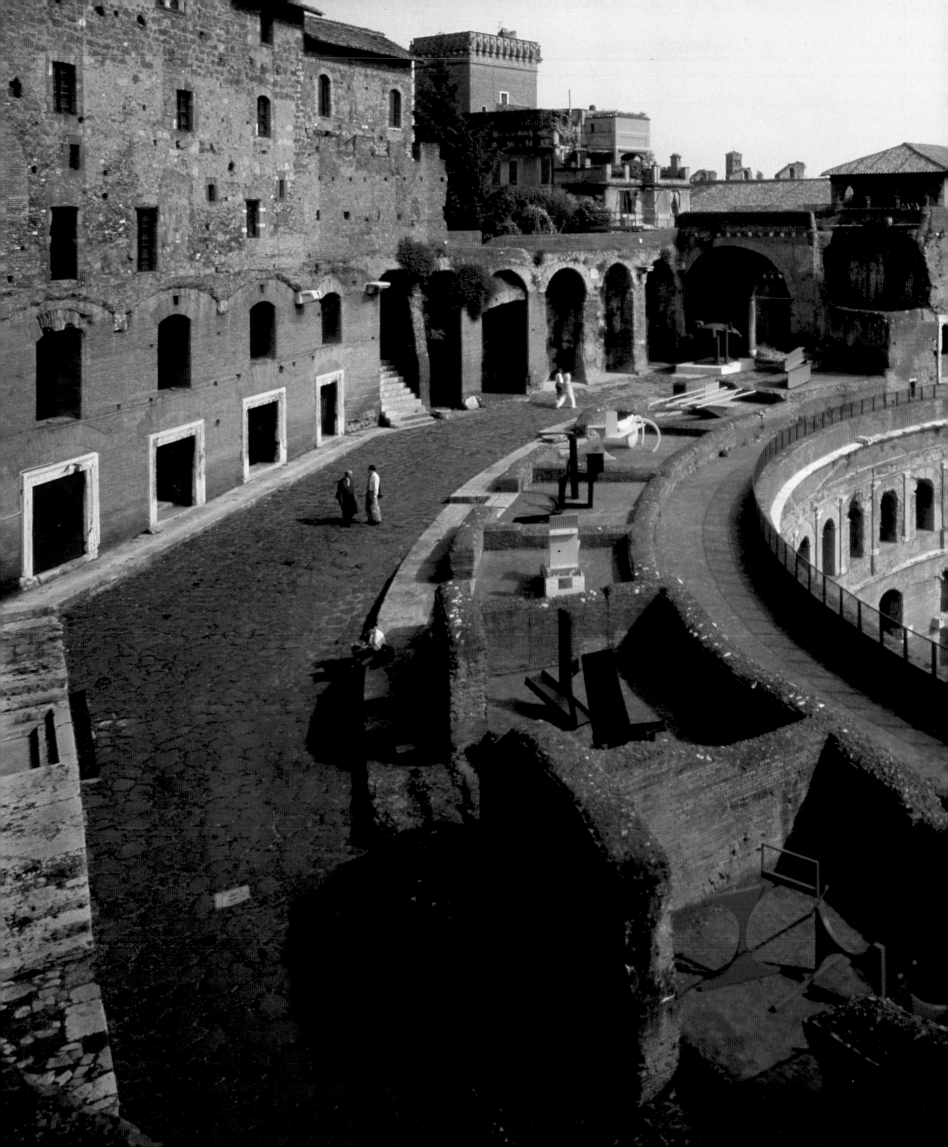

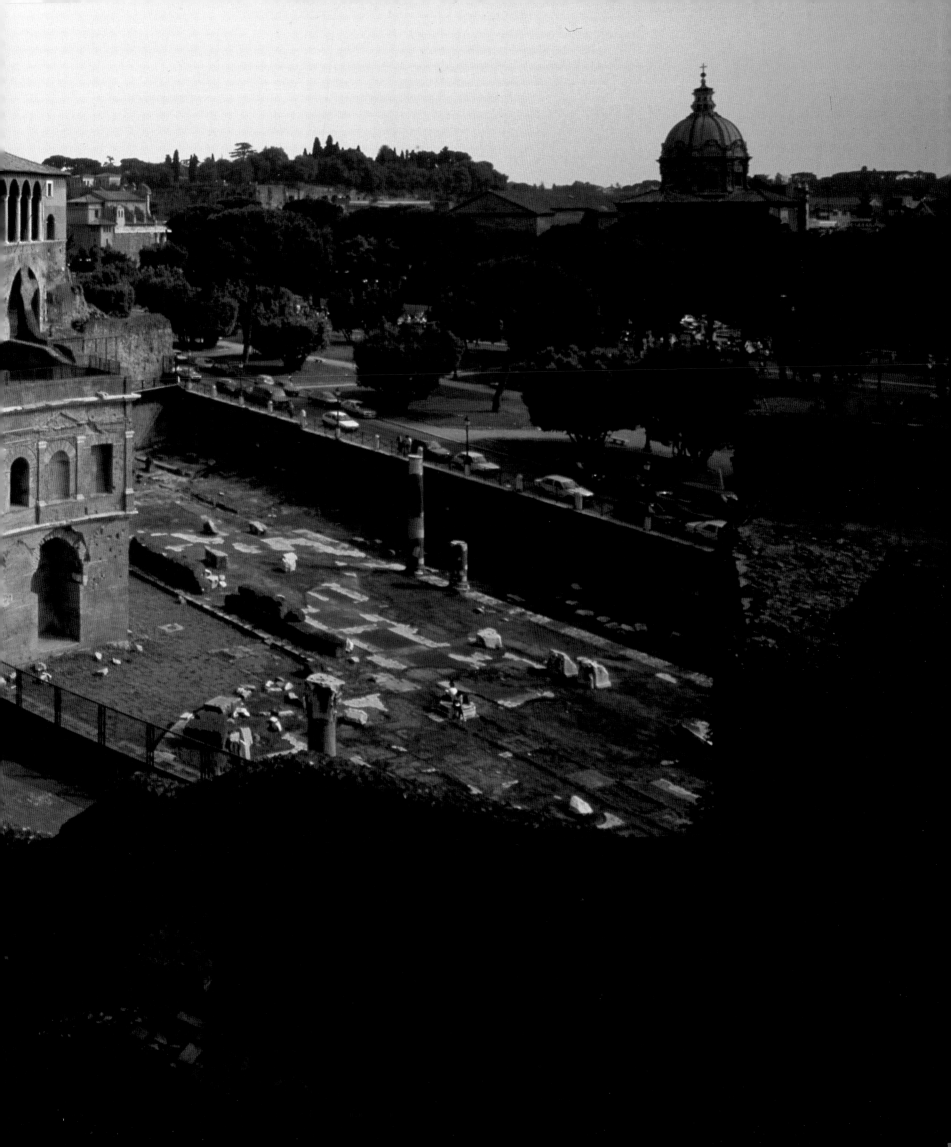

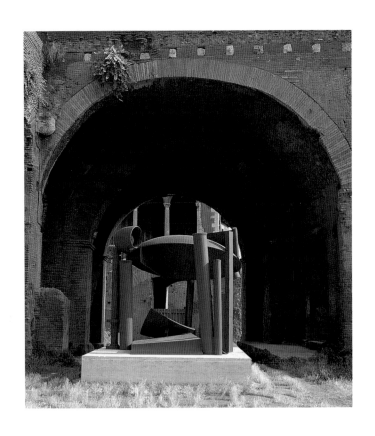

PLATE IV

'NORTH OF ROME' 1989

(3 5)

PLATE V

'NORTH OF ROME' 1989
SEEN FROM UNDER THE ARCHWAY
ON THE VIA BIBERATICA LOOKING
TOWARDS THE UPPER LEVELS OF
THE TRAJAN MARKETS

(3 5)

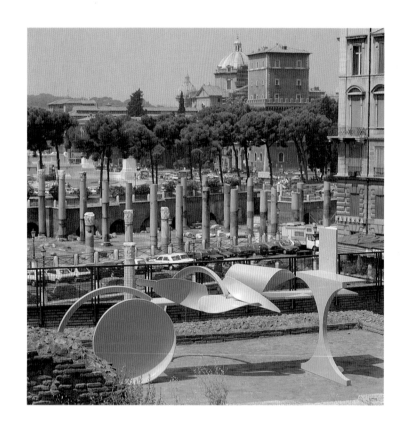

PLATE VI

'SUN FEAST' 1969-70
WITH THE VIEW TOWARDS TRAJAN'S
COLUMN AND THE FORUM

(15)

PLATE VII

'SUN FEAST' 1969-70
IN ONE OF THE RUINED MARKET
SPACES ADJOINING THE VIA
BIBERATICA

(15)

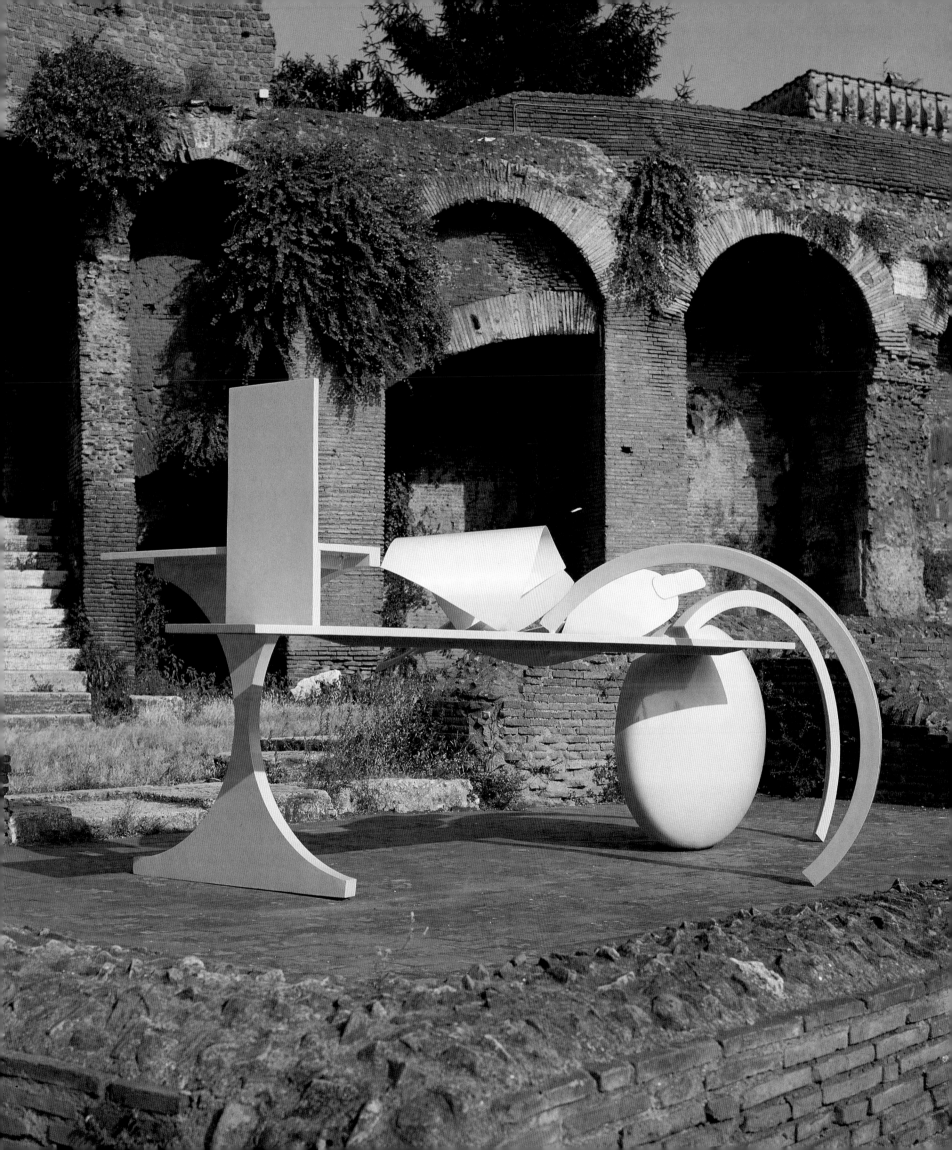

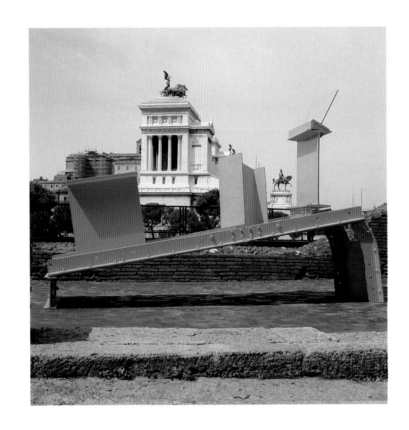

PLATE VIII

'MIDDAY' 1960
SEEN WITH THE MONUMENT TO
VITTORIO EMANUELE II IN THE
BACKGROUND

(1)

PLATE IX

'MIDDAY' 1960
SEEN ALONGSIDE THE VIA
BIBERATICA

(1)

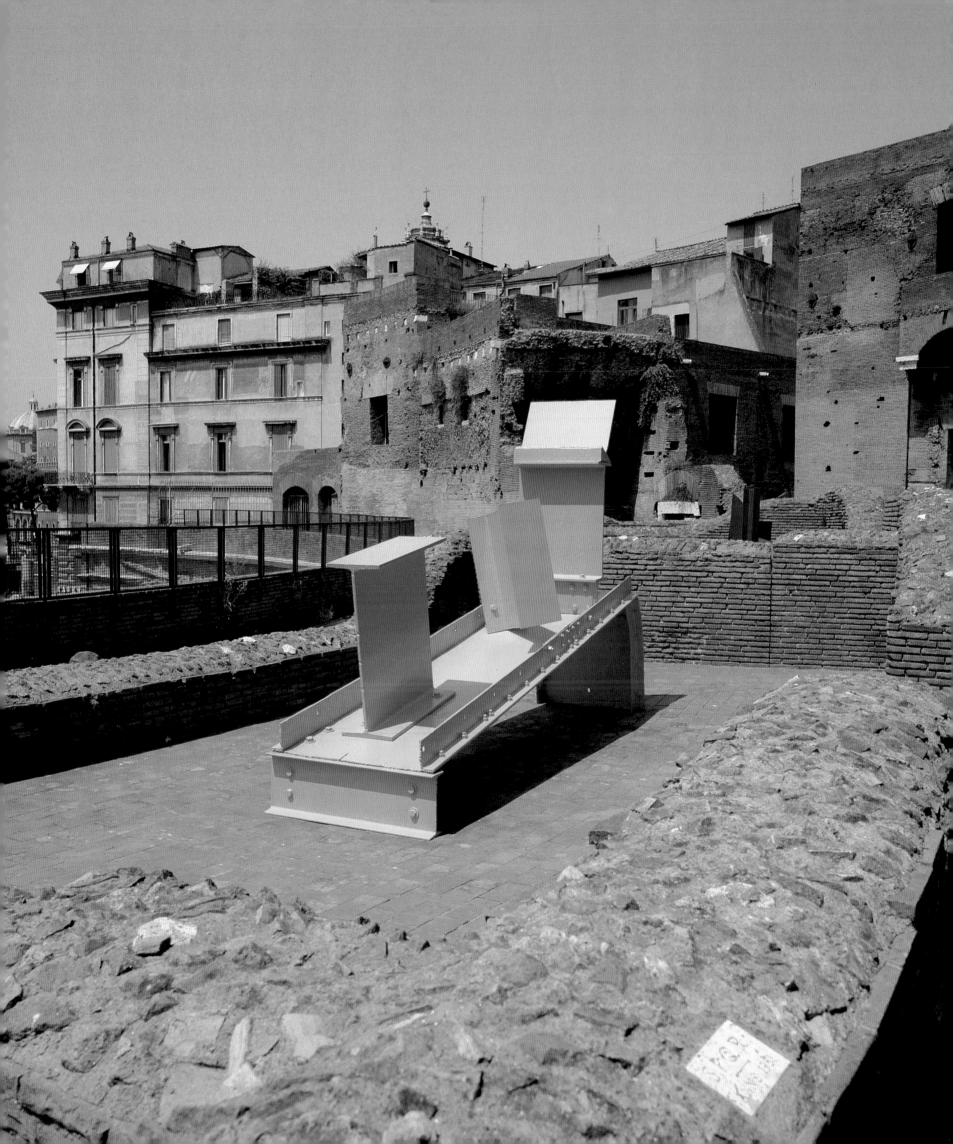

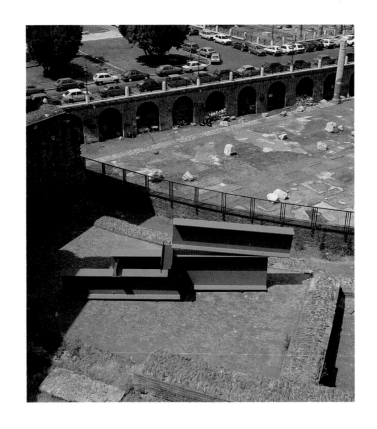

PLATE X

'SCULPTURE SEVEN' 1961
SEEN FROM ABOVE LOOKING TOWARDS
THE FORUM OF TRAJAN

(3)

PLATE X1

'SCULPTURE SEVEN' 1961
SEEN FROM THE VIA BIBERATICA

(3)

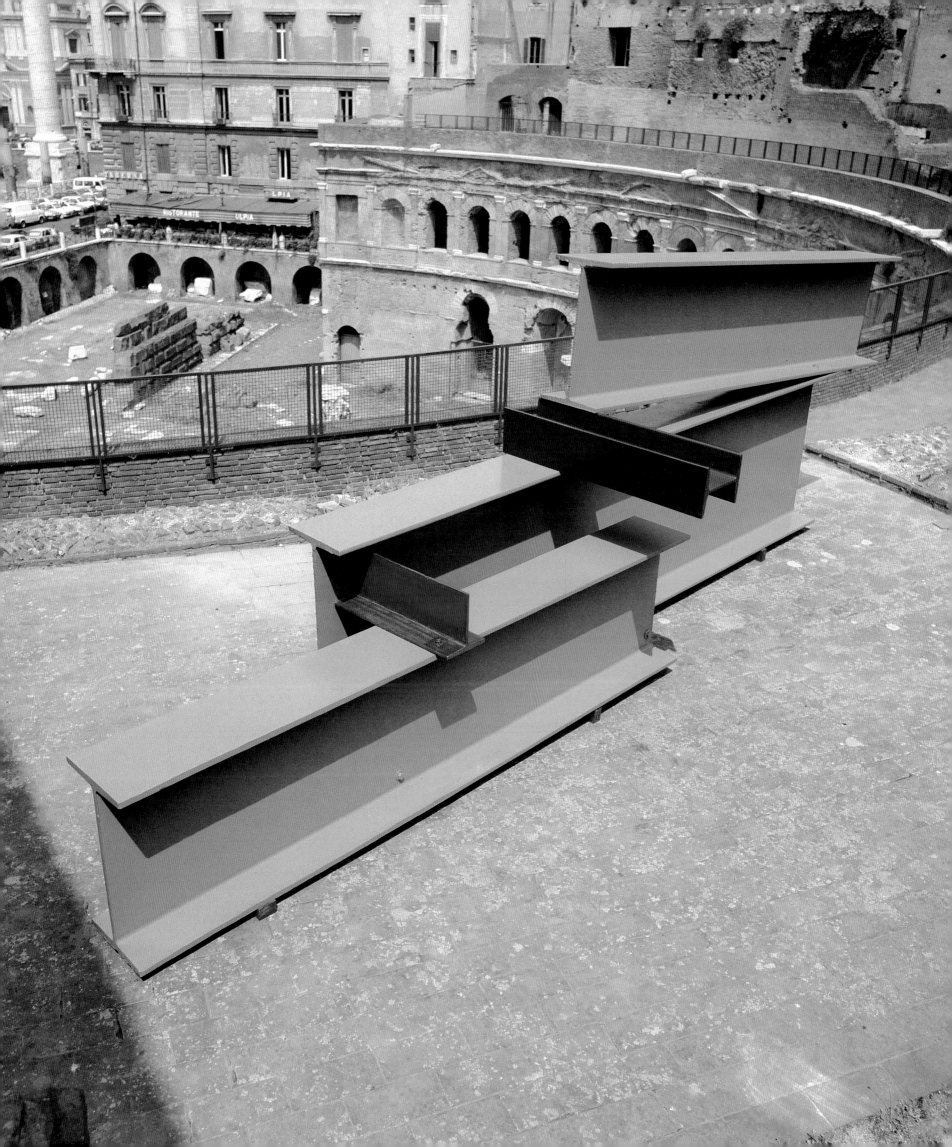

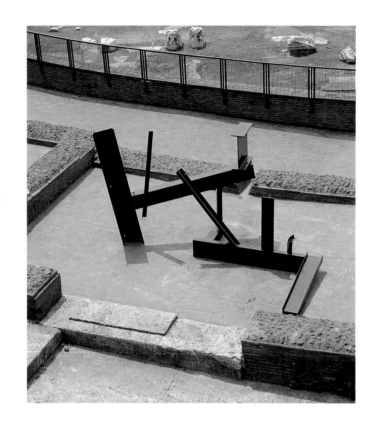

PLATE XII

'SCULPTURE TWO' 1962
SEEN FROM ABOVE

(5)

PLATE XIII

'SCULPTURE TWO' 1962
SEEN FROM THE VIA BIBERATICA

(5)

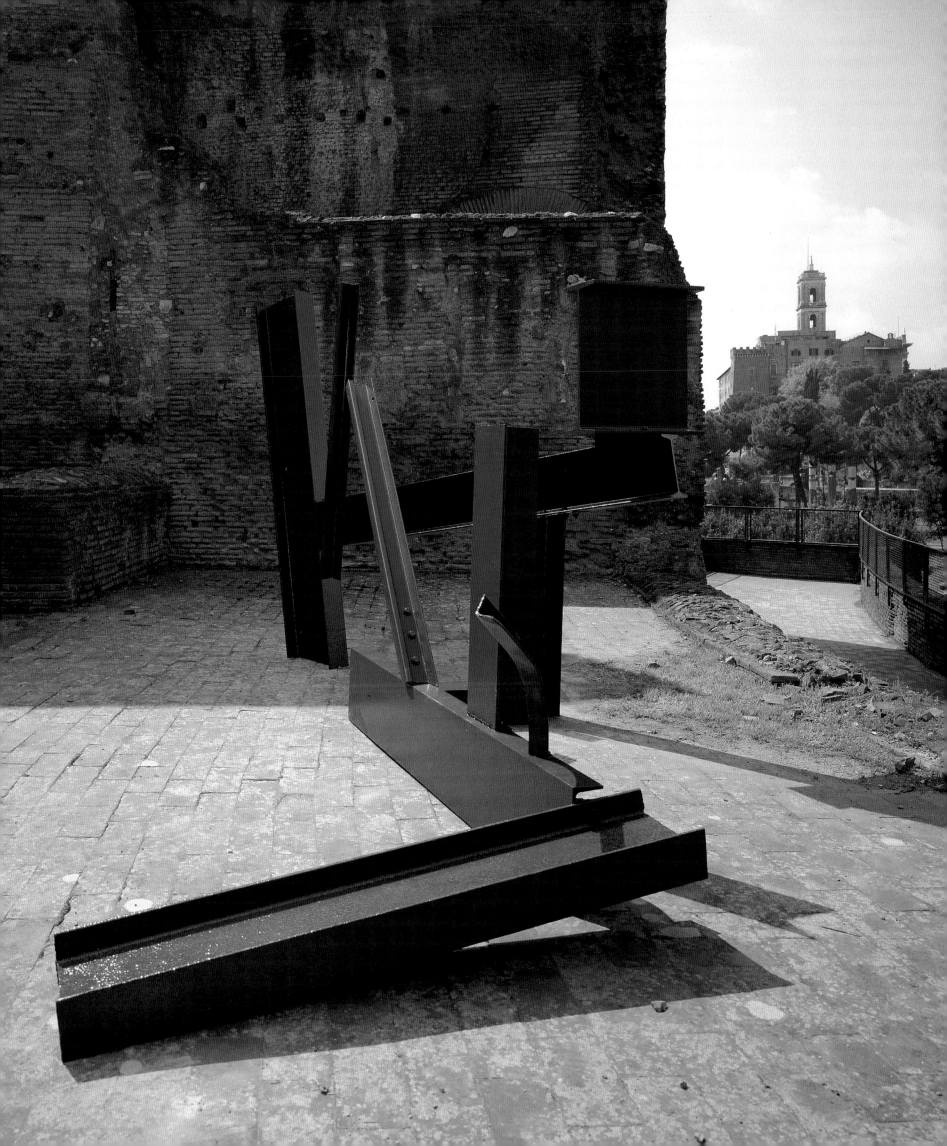

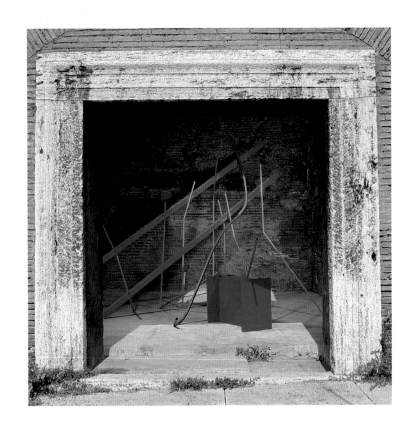

PLATE XIV

'MONTH OF MAY' 1963
SEEN THROUGH THE PORTAL ADJOINING
THE VIA BIBERATICA

(6)

PLATE XV

THE LOWER LEVELS OF THE TRAJAN MARKETS
WITH 'SCULPTURE TWO' 1962
IN THE FOREGROUND AND 'MONTH OF MAY' 1963
VISIBLE ON THE OTHER SIDE OF
THE VIA BIBERATICA

(5 & 6)

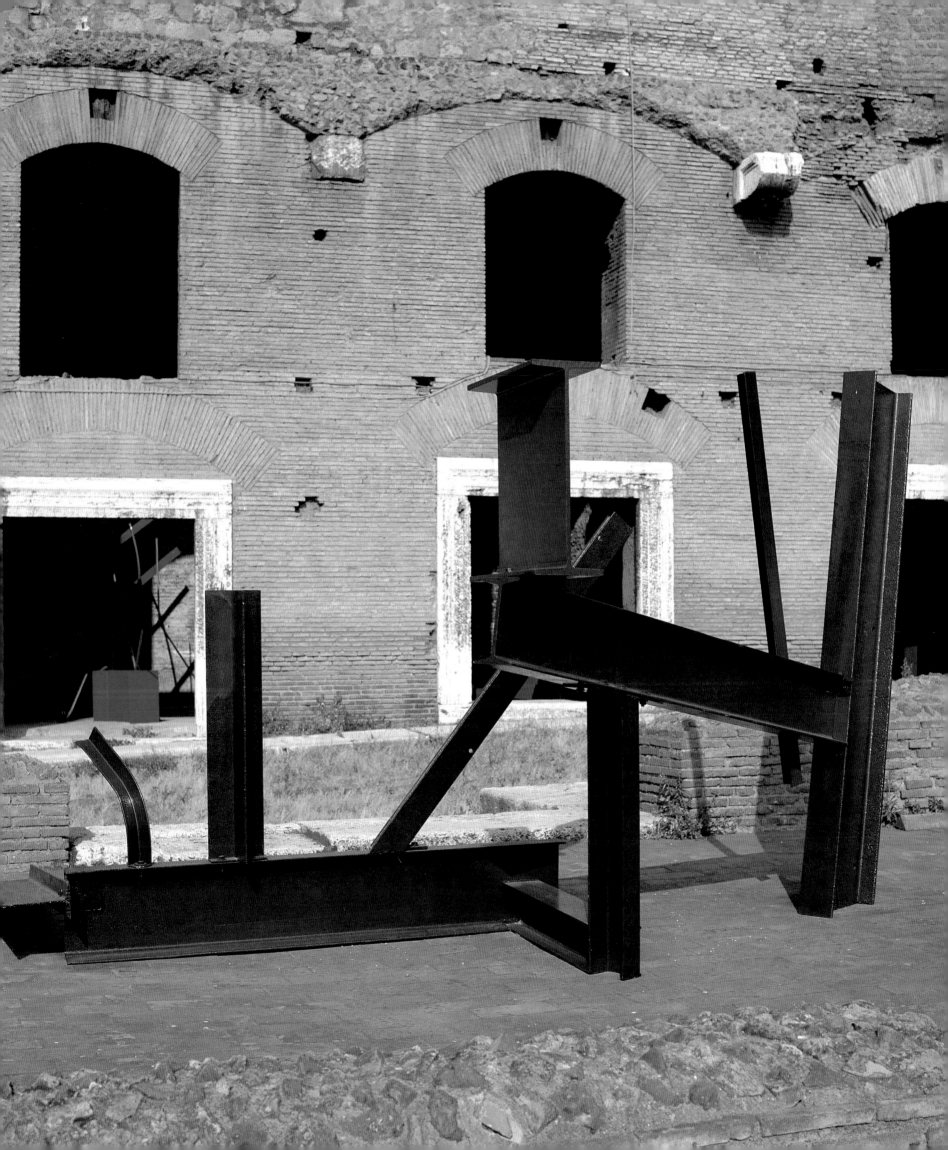

PLATE XVI

'THE HORSE' 1961
SEEN LOOKING TOWARDS
THE LOWER LEVELS OF THE
TRAJAN MARKETS

(2)

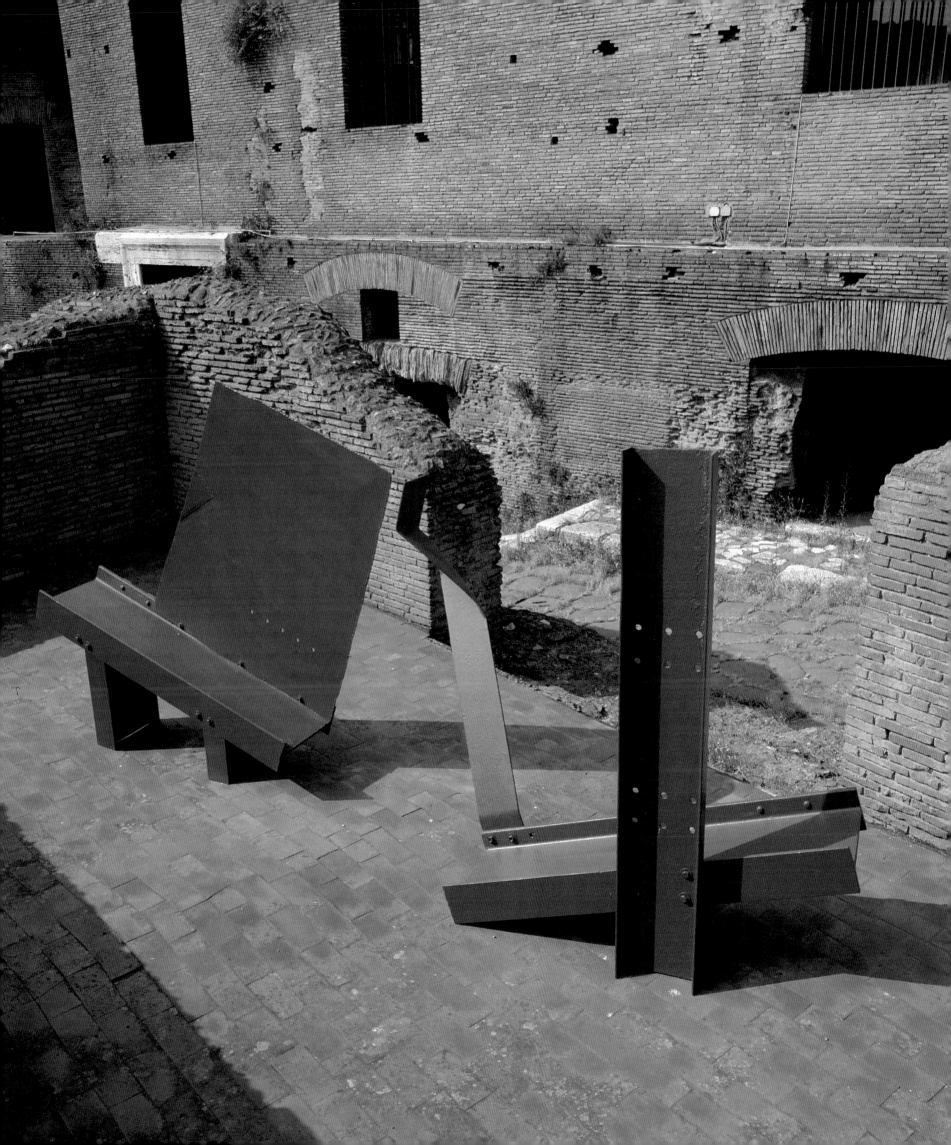

PLATE XVII

'SPAN' 1966
ADJOINING THE VIA BIBERATICA

(9)

PLATE XVIII

'SPAN' 1966 SEEN WITH PART OF
'MIDNIGHT GAP' 1976-78
IN THE BACKGROUND ADJOINING
THE STAIRCASE LEADING TO
THE UPPER LEVELS OF THE
TRAJAN MARKETS

(9 & 23)

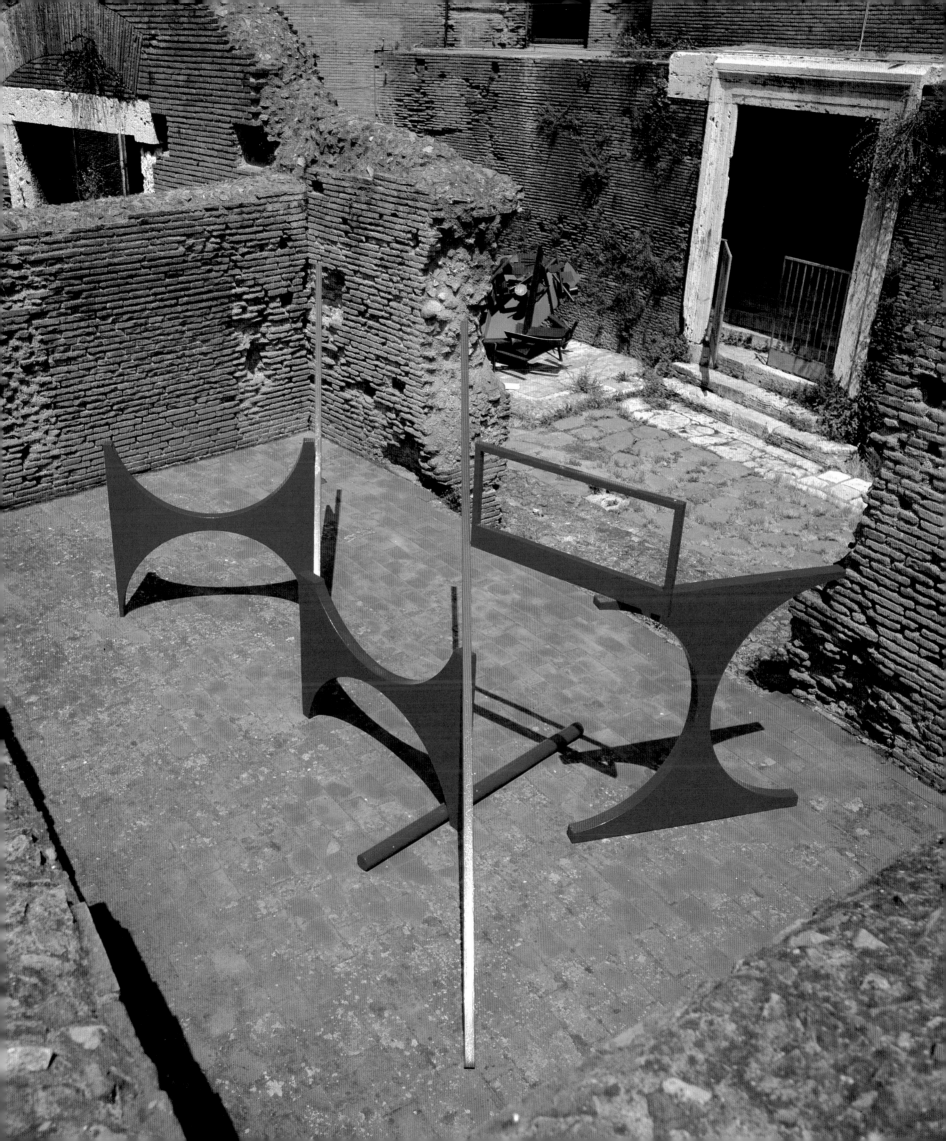

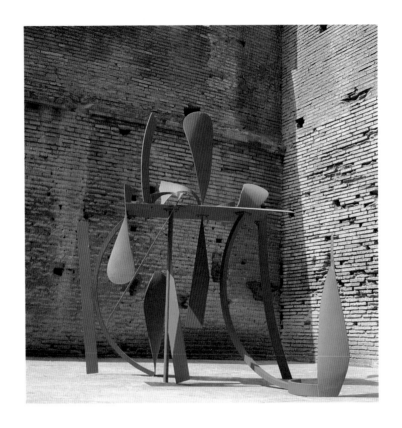

PLATE XIX

'ORANGERIE' 1969

(13)

PLATE XX

'ORANGERIE' 1969
SEEN THROUGH THE PORTAL ADJOINING
THE VIA BIBERATICA

(13)

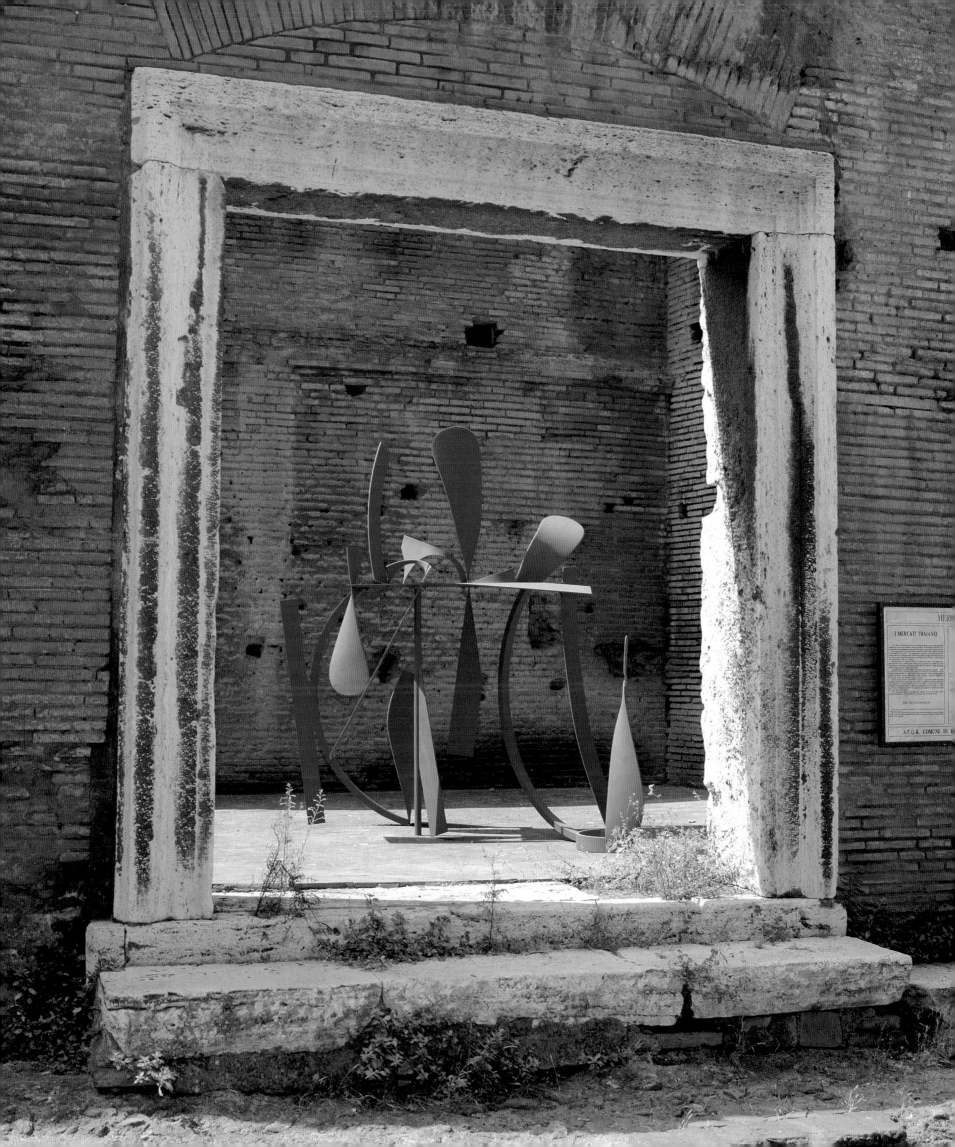

PLATE XXI

THE EXTERIOR OF THE LOWER AND
UPPER LEVELS OF THE TRAJAN MARKETS.
JUST VISIBLE ARE
'MIDNIGHT GAP' 1976-78
AND PART OF
'EARLY ONE MORNING' 1962

(23 & 4)

PLATE XXII

'MIDNIGHT GAP' 1976-78
SEEN FROM THE VIA BIBERATICA

(23)

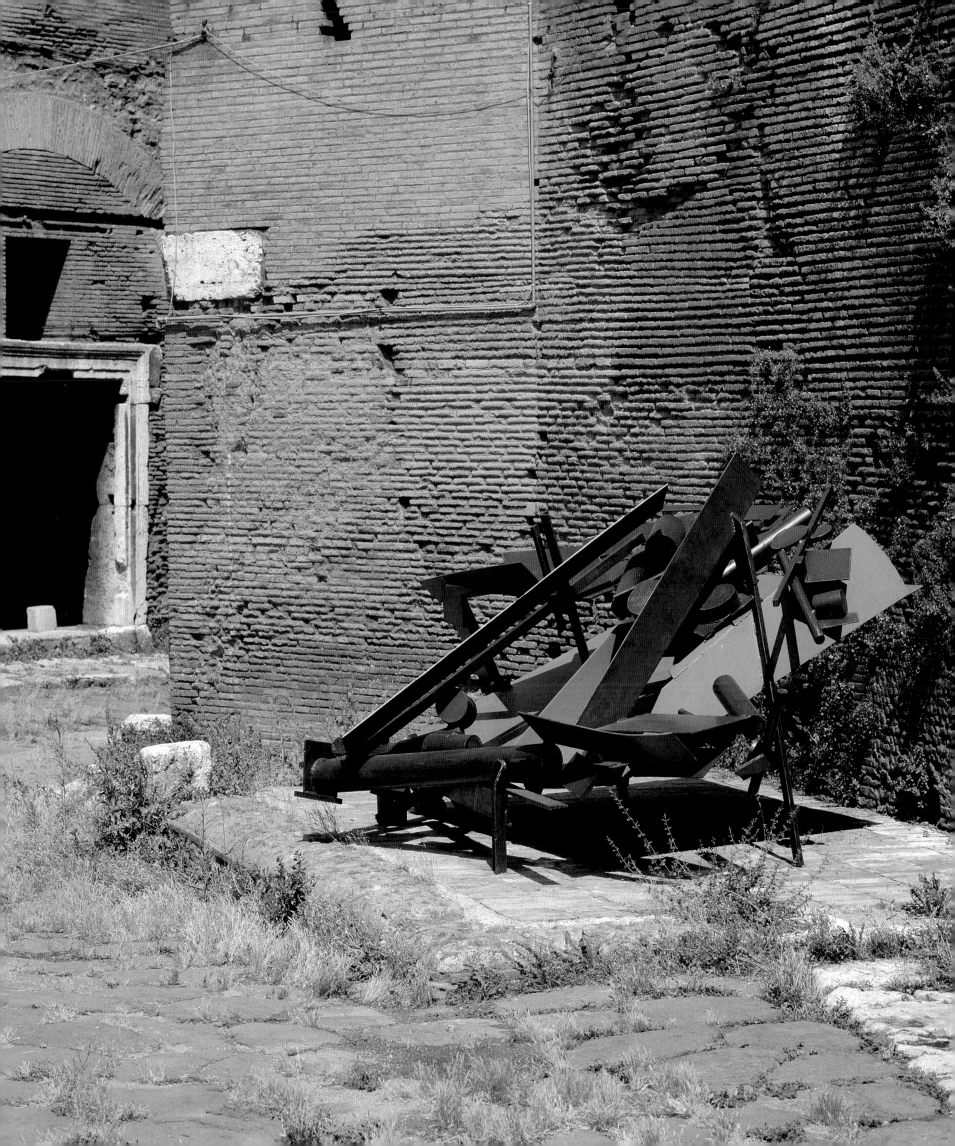

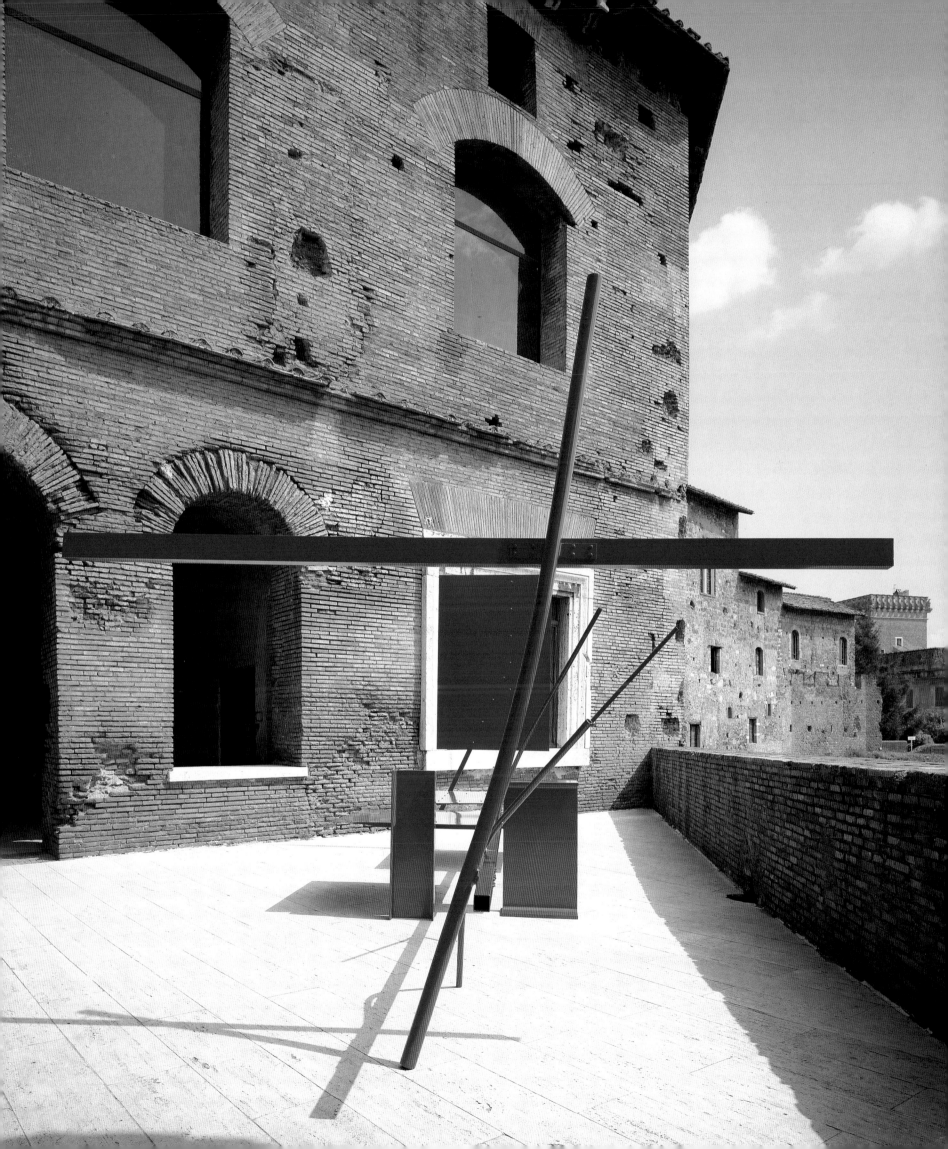

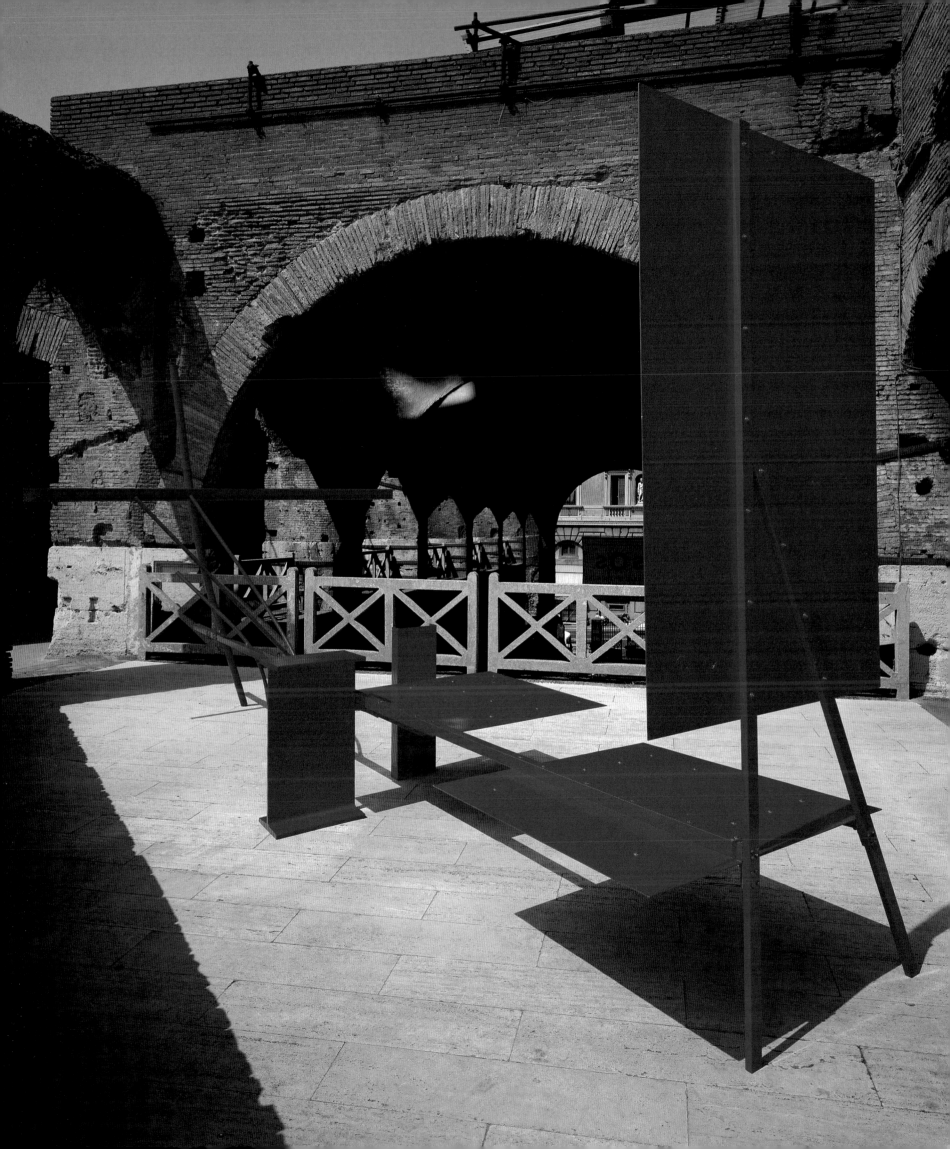

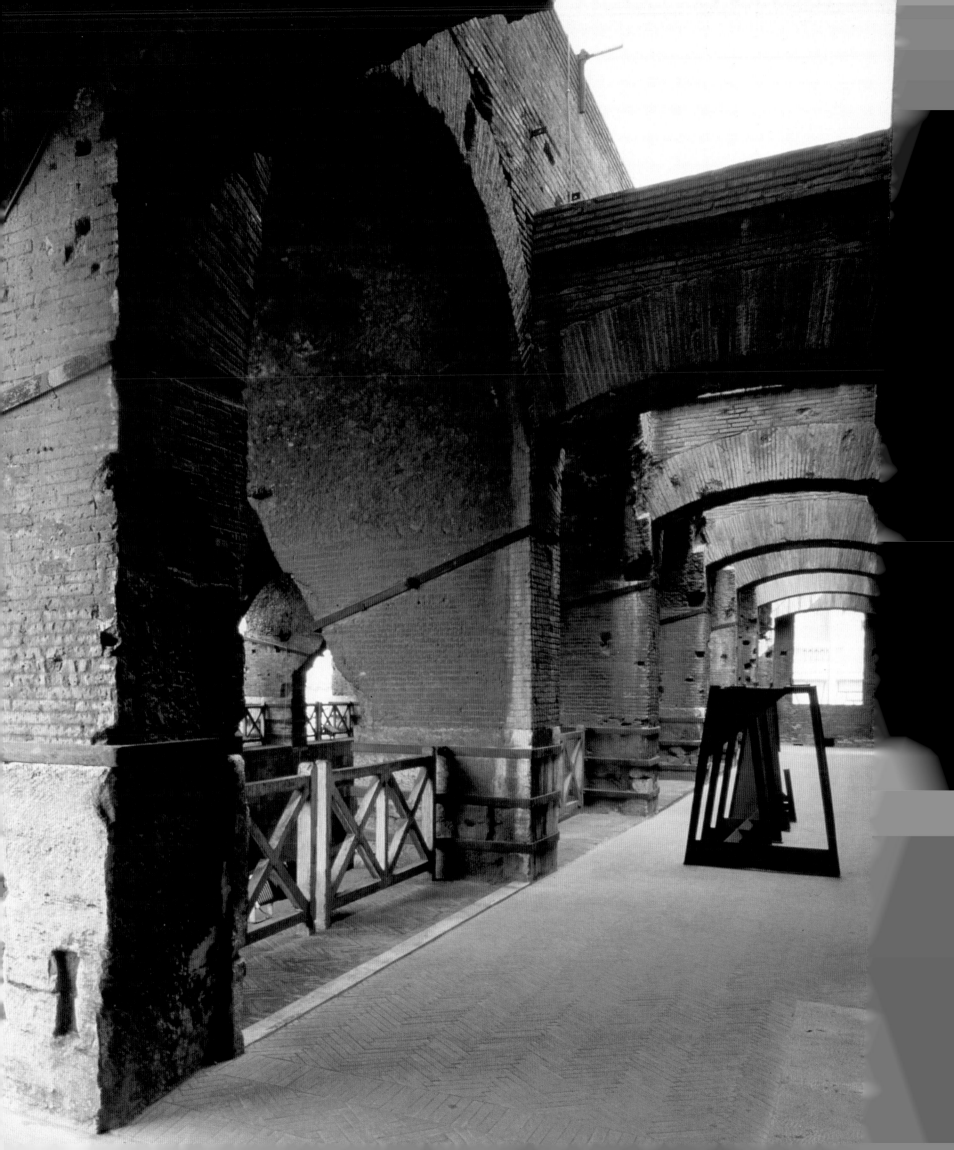

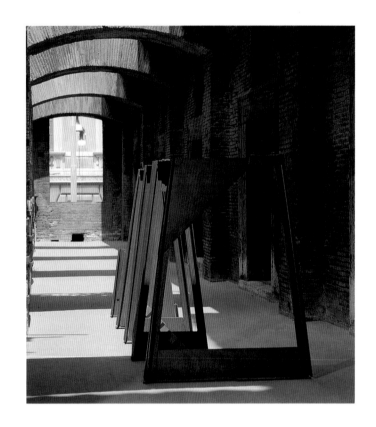

PLATE XXVI

'END GAME' 1971-74
SEEN LOOKING ALONG PART OF THE
UPPER ARCADE

(18)

PLATE XXVII

'END GAME' 1971-74
SEEN LOOKING TOWARDS THE
INNER CHAMBERS OF THE
TRAJAN MARKETS

(18)

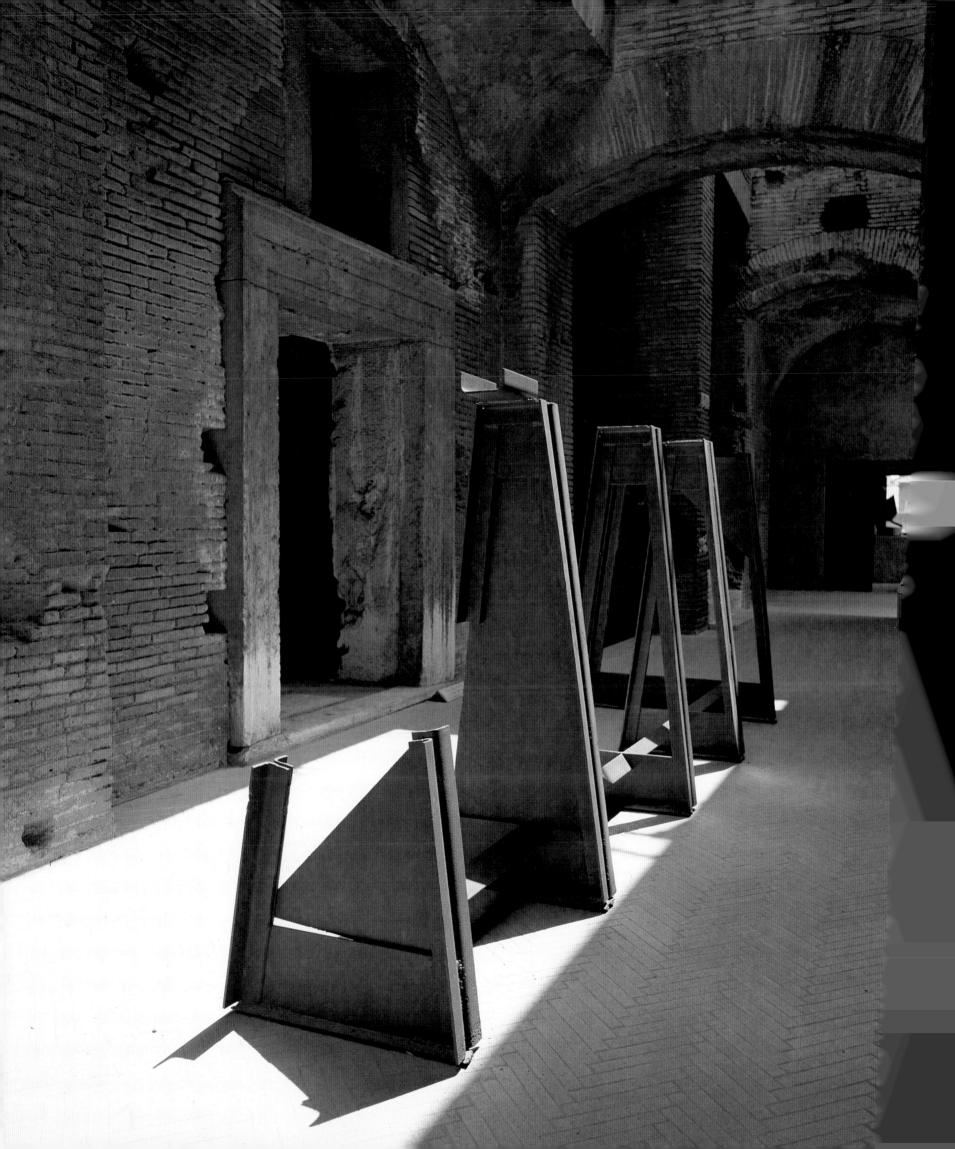

PLATE XXVIII

'DEEP NORTH' 1969-70

(16)

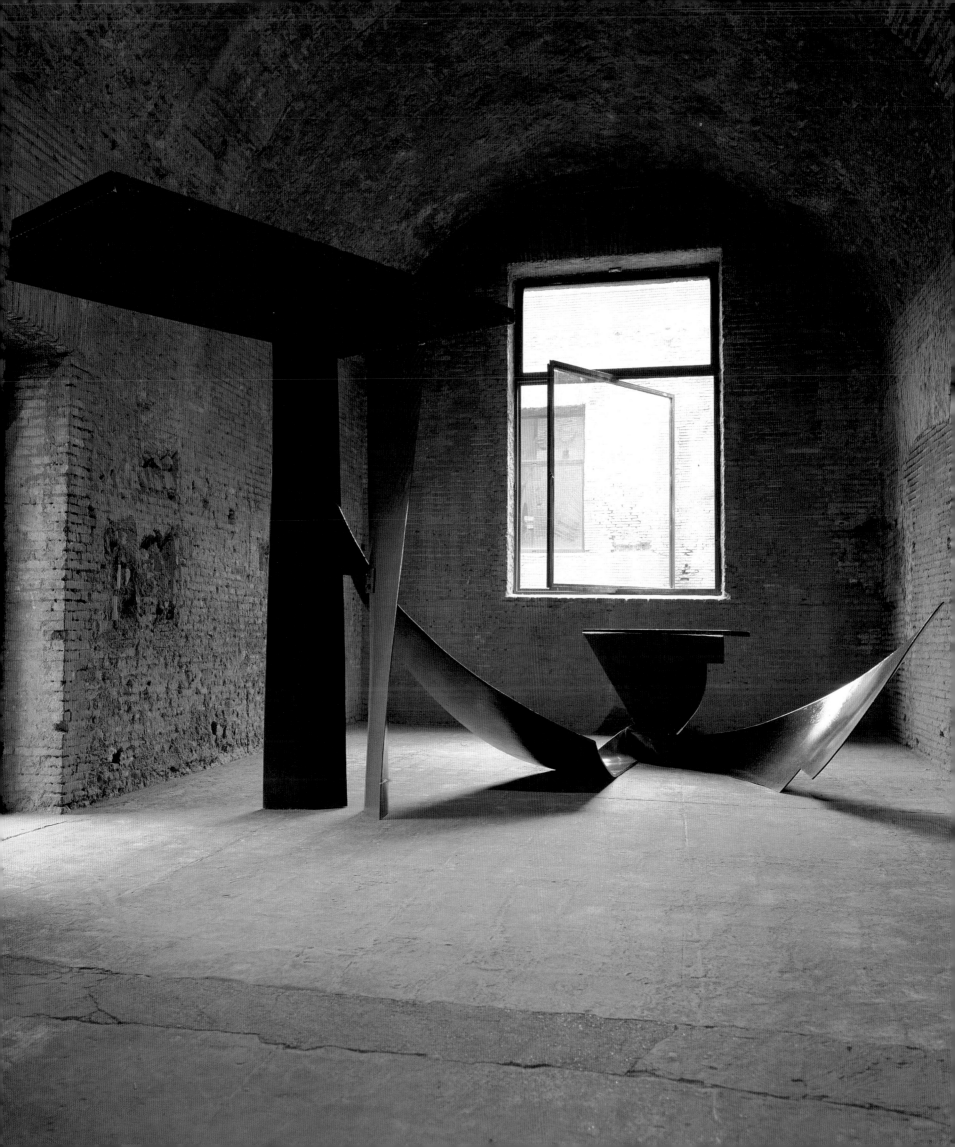

PLATE XXIX

'VEDUGGIO SOUND'
1972-73

(19)

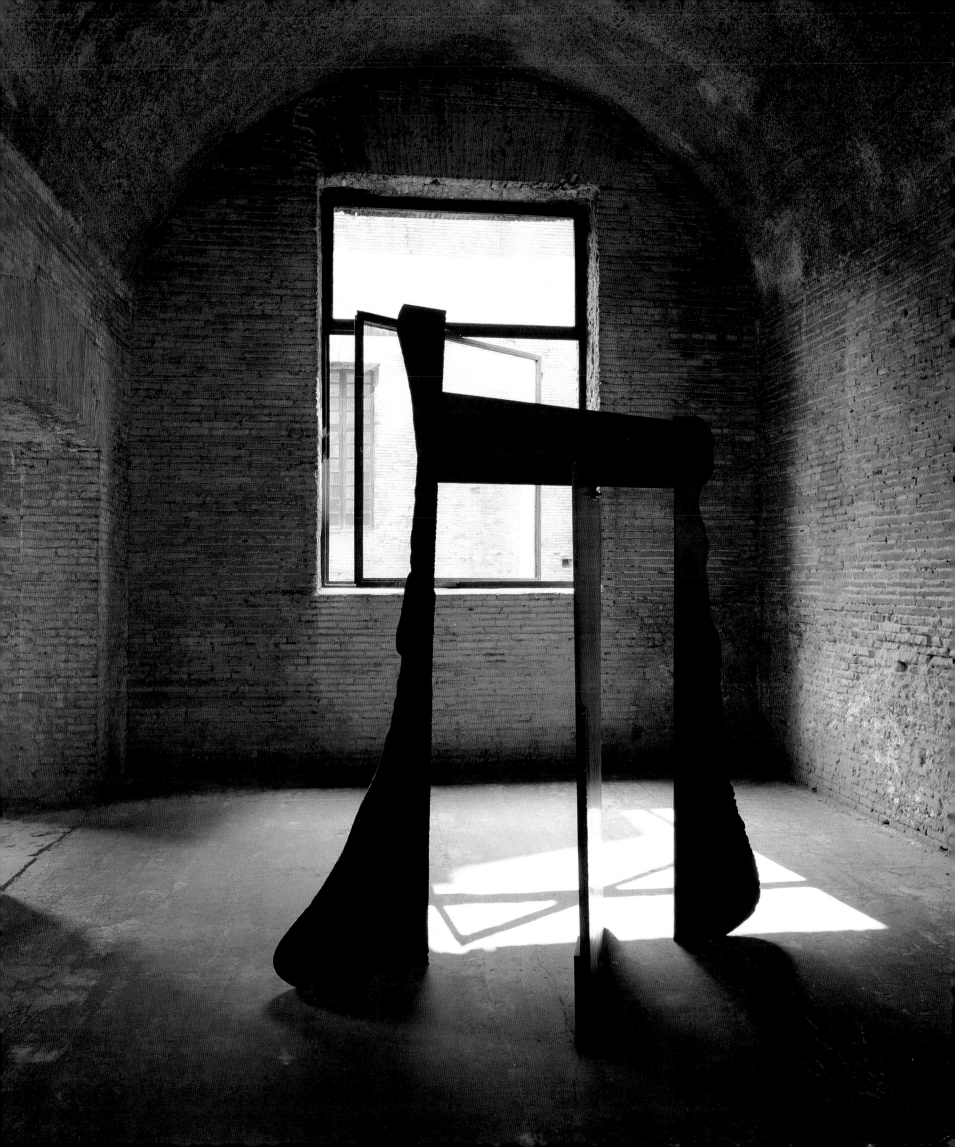

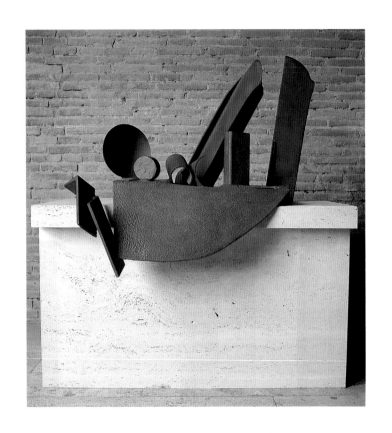

PLATE XXX

TABLE PIECE Y-49 'AFTER PICASSO'
1985

(28)

PLATE XXXI

FLOOR PIECE 'SUMMER TABLE'
1990

(38)

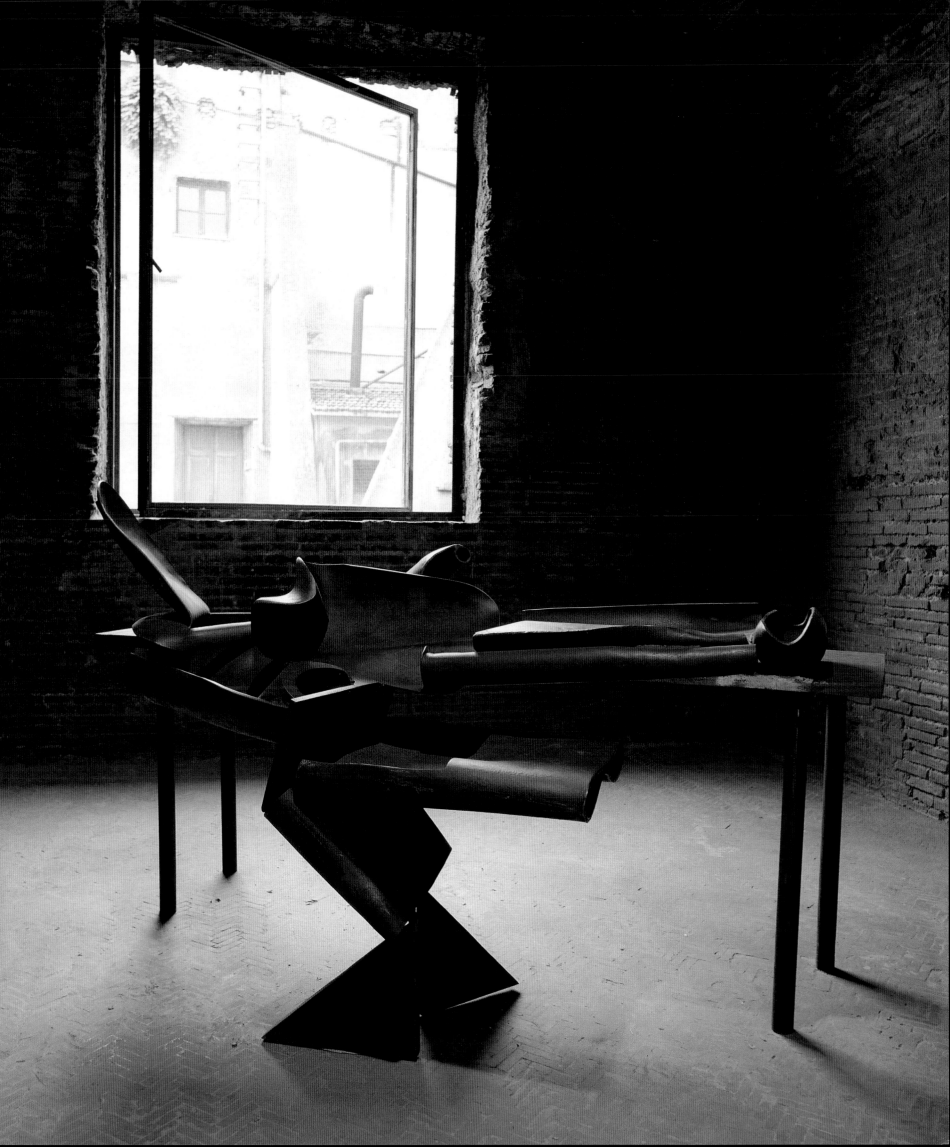

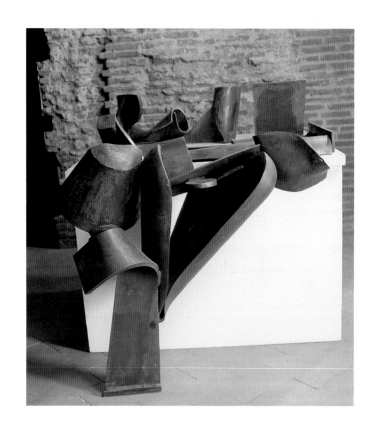

PLATE XXXII

TABLE PIECE 'CLEAR SIGHT'
1989-90

(37)

PLATE XXXIII

'ROMAN'
1970-76

(22)

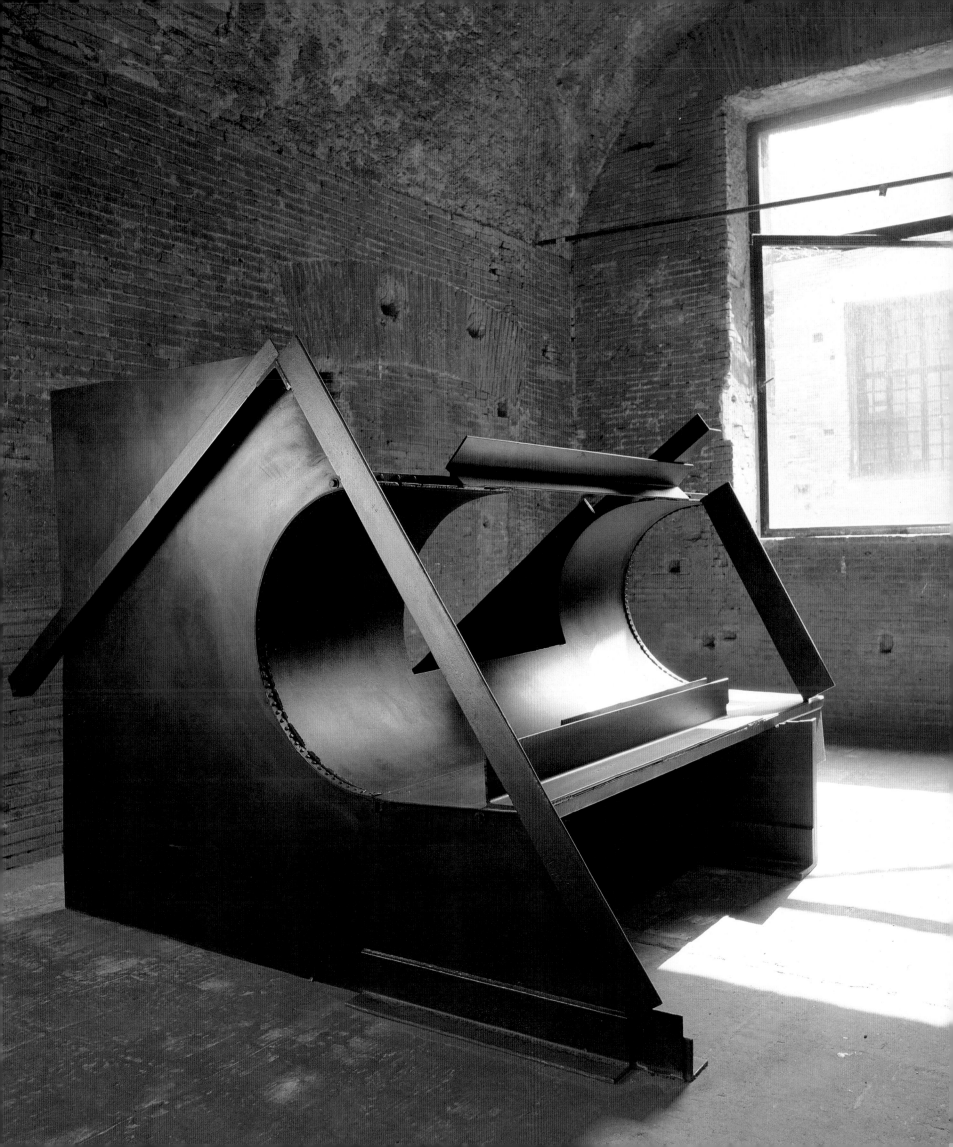

PLATE XXXIV

'DURHAM PURSE'
1973-74

(21)

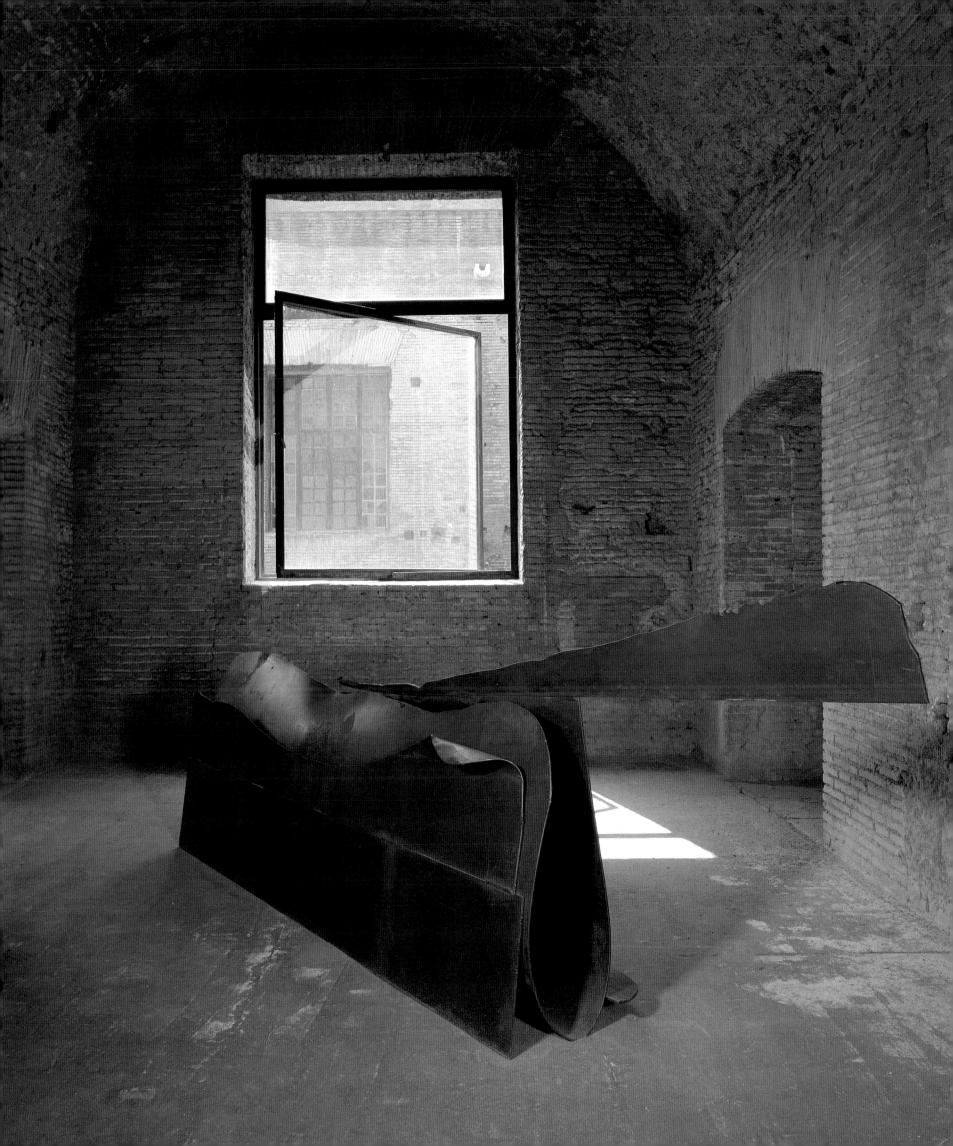

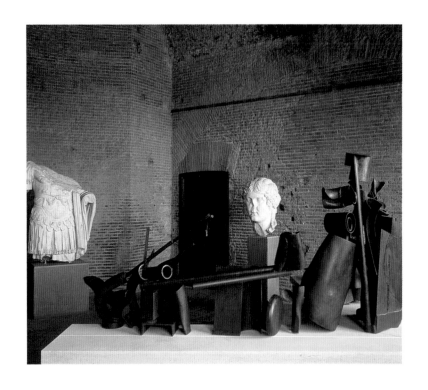

PLATE XXXV

A DETAIL OF TABLE PIECE Y-92
'TRIUMPH OF CAESAR' 1987
SEEN WITH SOME OF THE ROMAN
STATUES FOUND ON THE SITE OF
THE TRAJAN MARKETS

(30)

PLATE XXXVI

LOOKING THROUGH A PORTAL
SHOWING A SIDE VIEW OF TABLE
PIECE 'LOOSE CHANGE' 1990

(36)

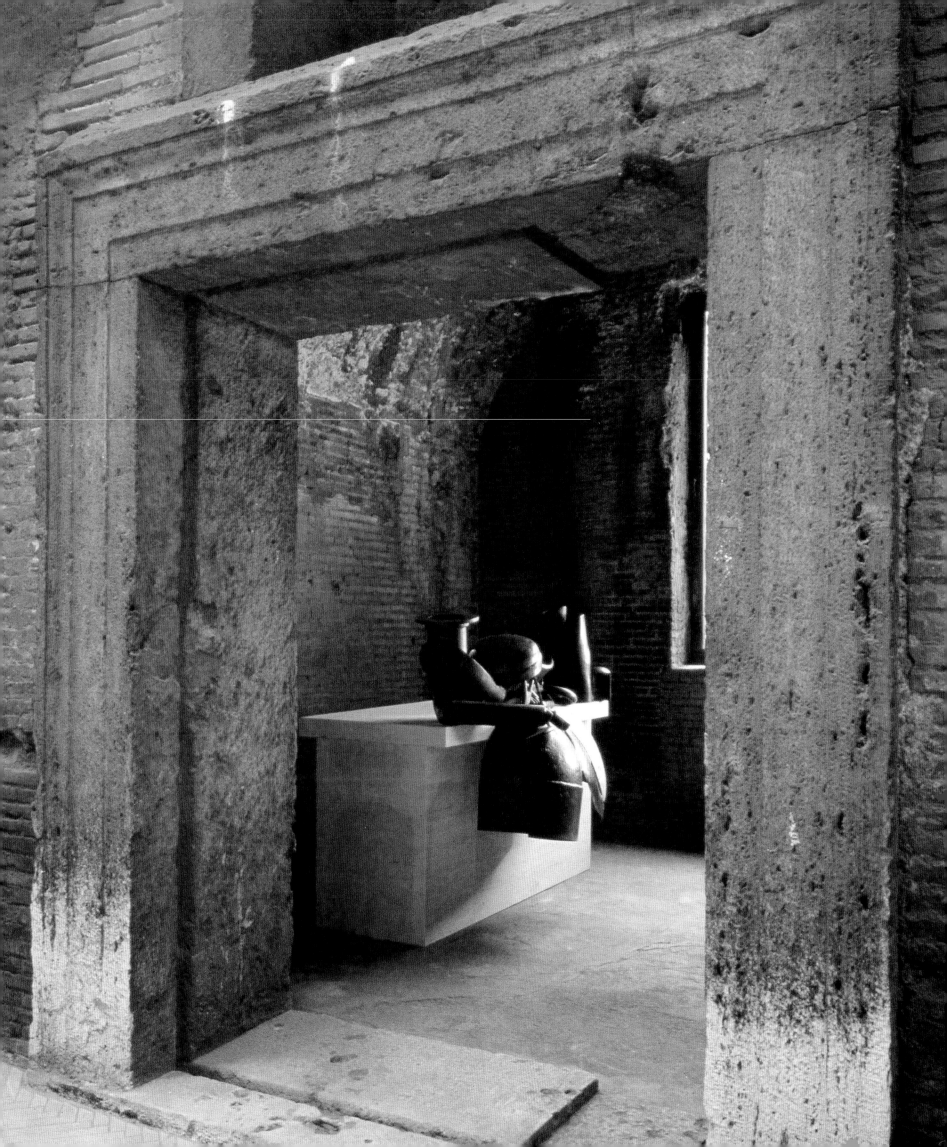

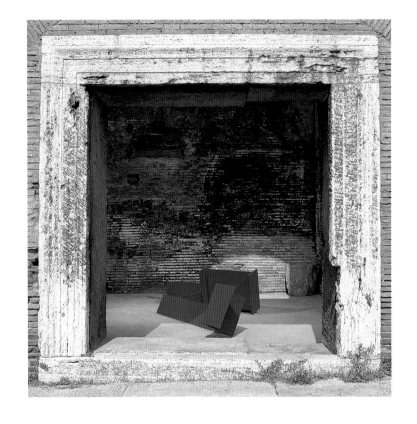

PLATE XXXVII

'SHAFTSBURY' 1965
SEEN THROUGH AN OUTER PORTAL

(8)

PLATE XXXVIII

'SHAFTSBURY' 1965

(8)

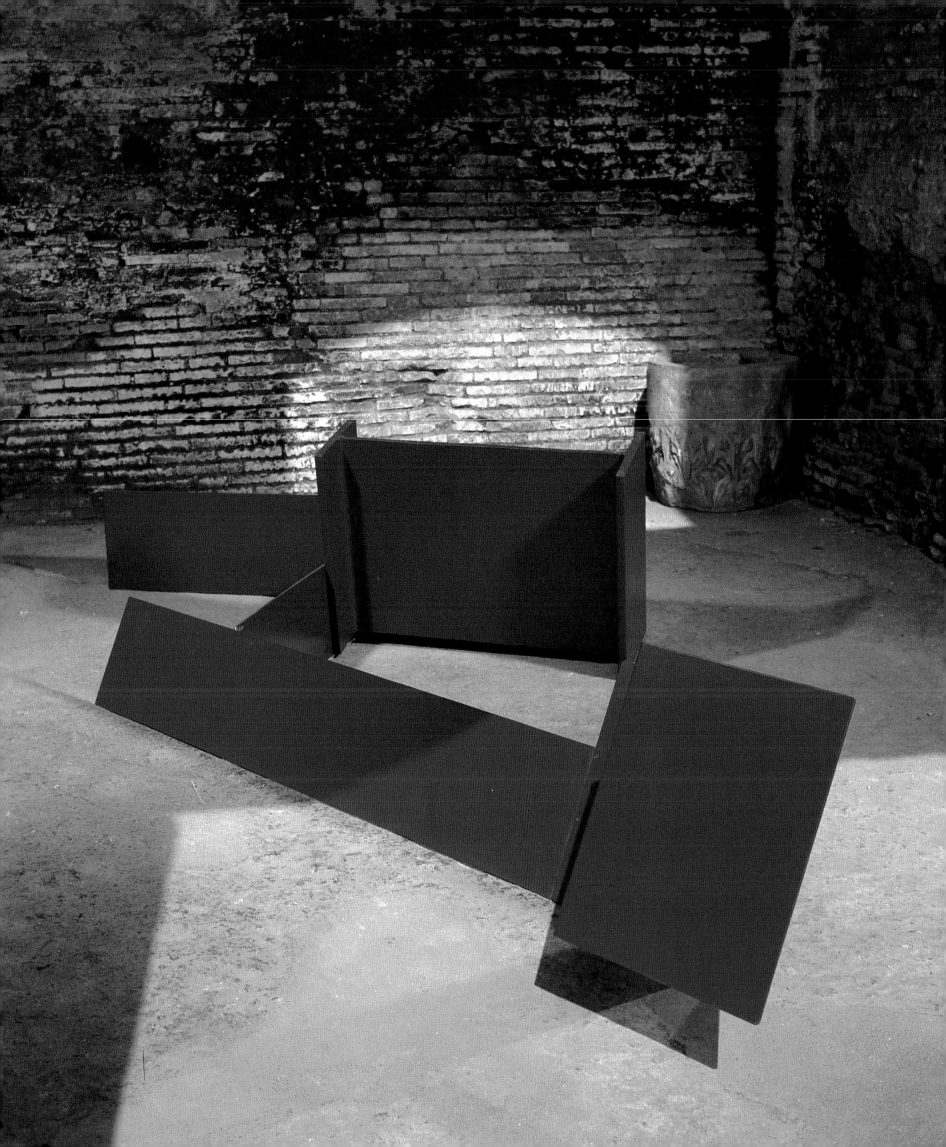

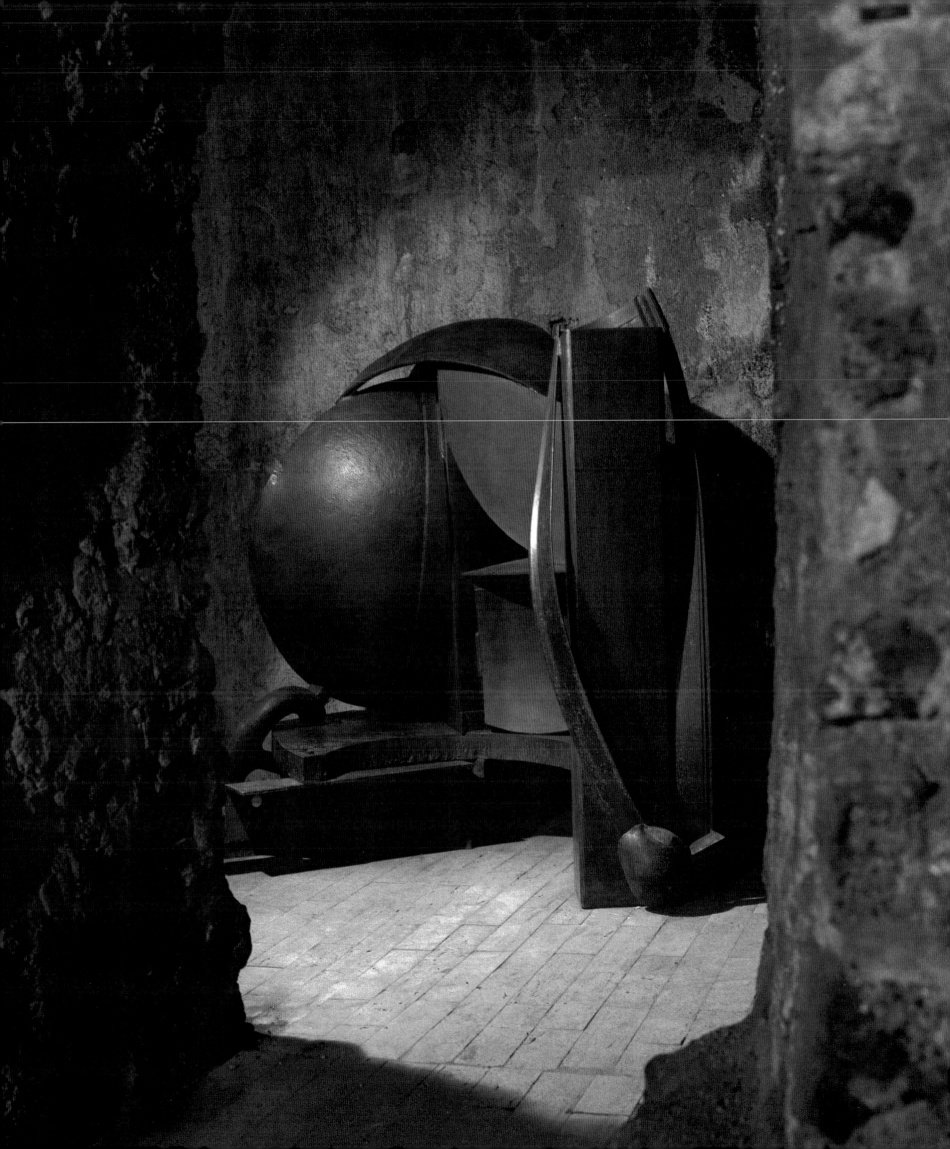

PLATE XL

'THE SOLDIER'S TALE' 1983

(25)

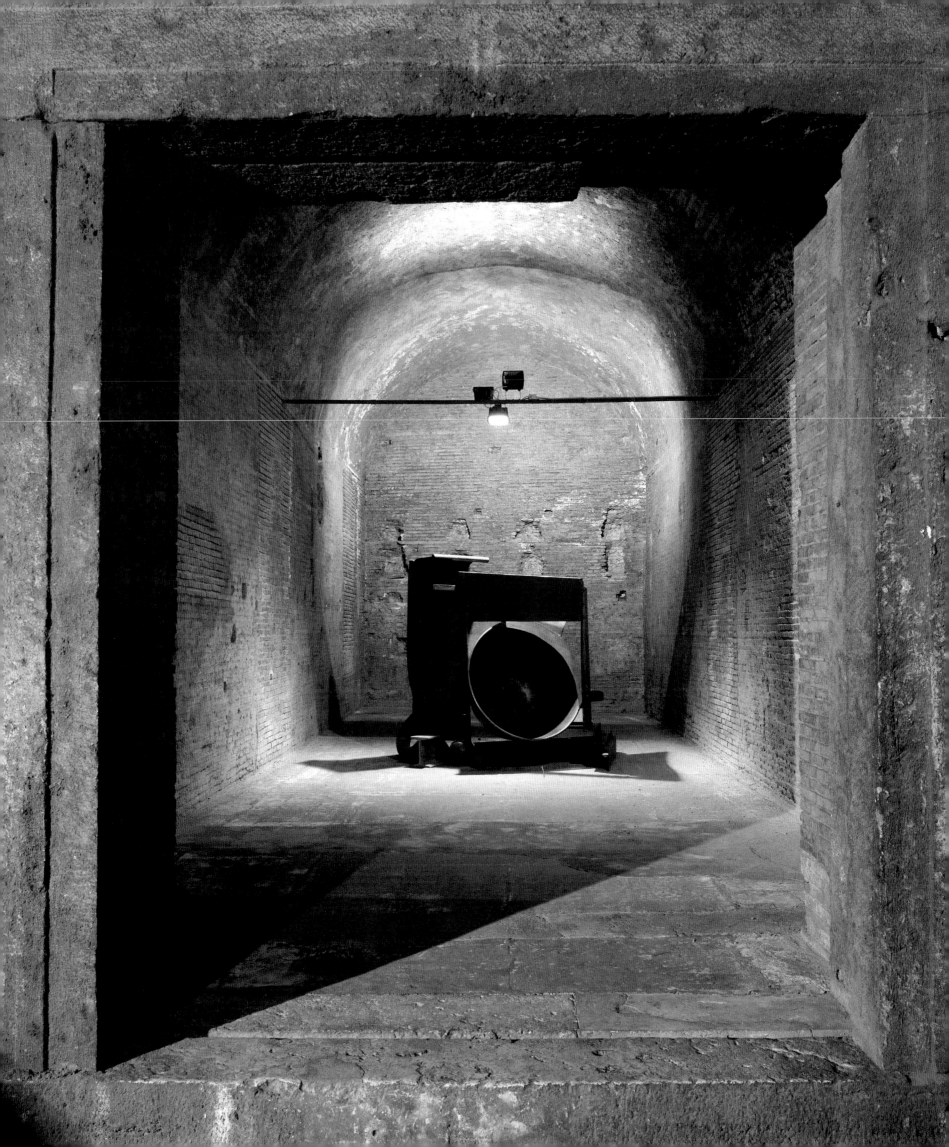

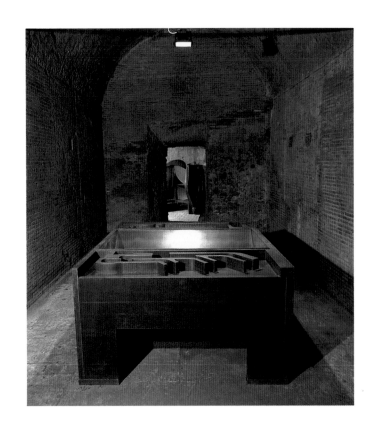

PLATE XLI

'NIGHT AND DREAMS' 1990-91
IN THE BACKGROUND
CAN BE SEEN A DETAIL OF
'ODALISQUE' 1983-84

(39 & 26)

PLATE XLII

'SUN GATE' 1986-88

(33)

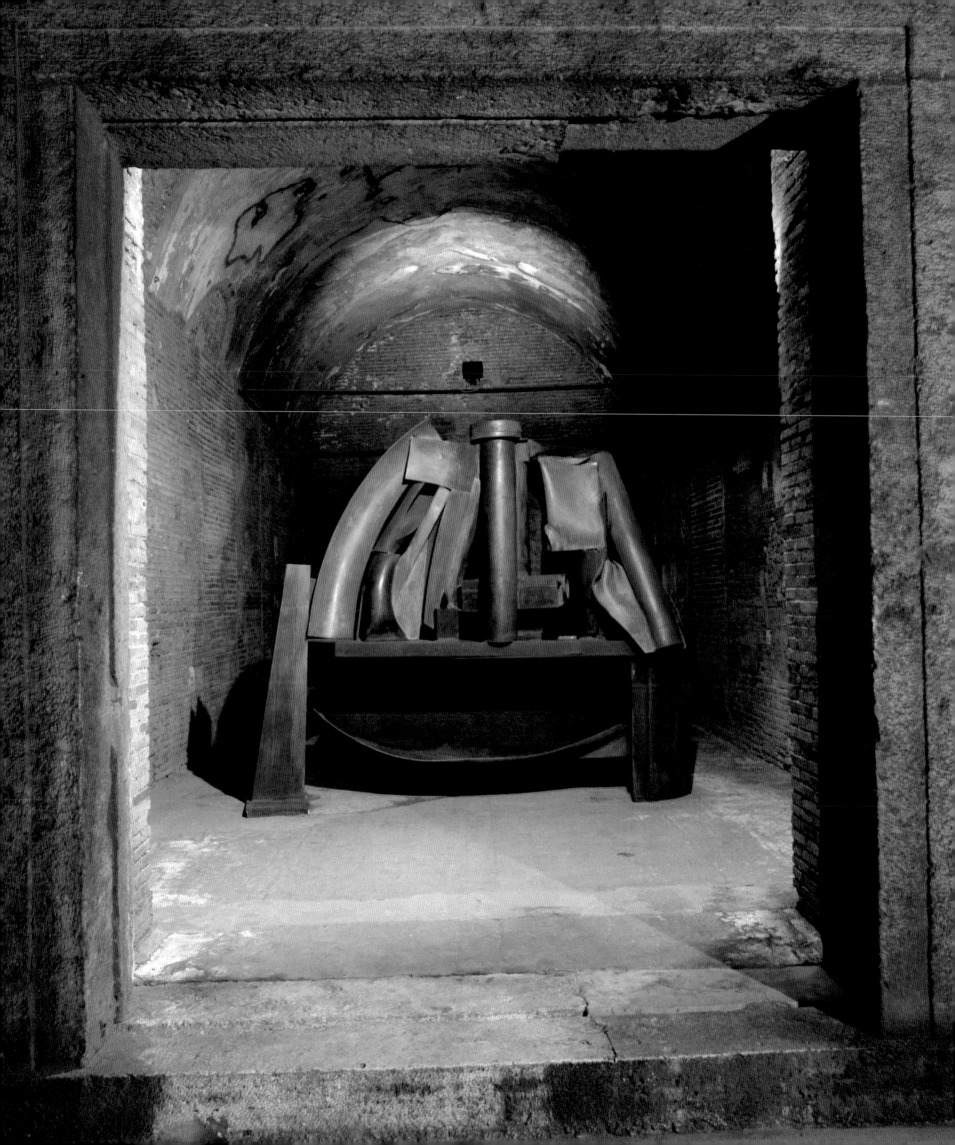

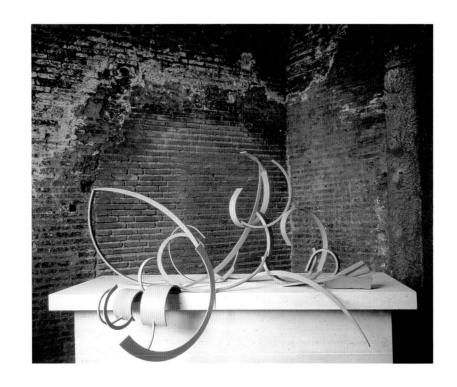

PLATE XLIII

TABLE PIECE LXXXVIII
'DELUGE' 1969

(14)

PLATE XLIV

'ORDNANCE' 1971
IN THE BACKGROUND CAN BE
SEEN A DETAIL OF
'AFTER OLYMPIA' 1986-87
AND PART OF THE UPPER
LEVEL ARCADE

(17 & 31)

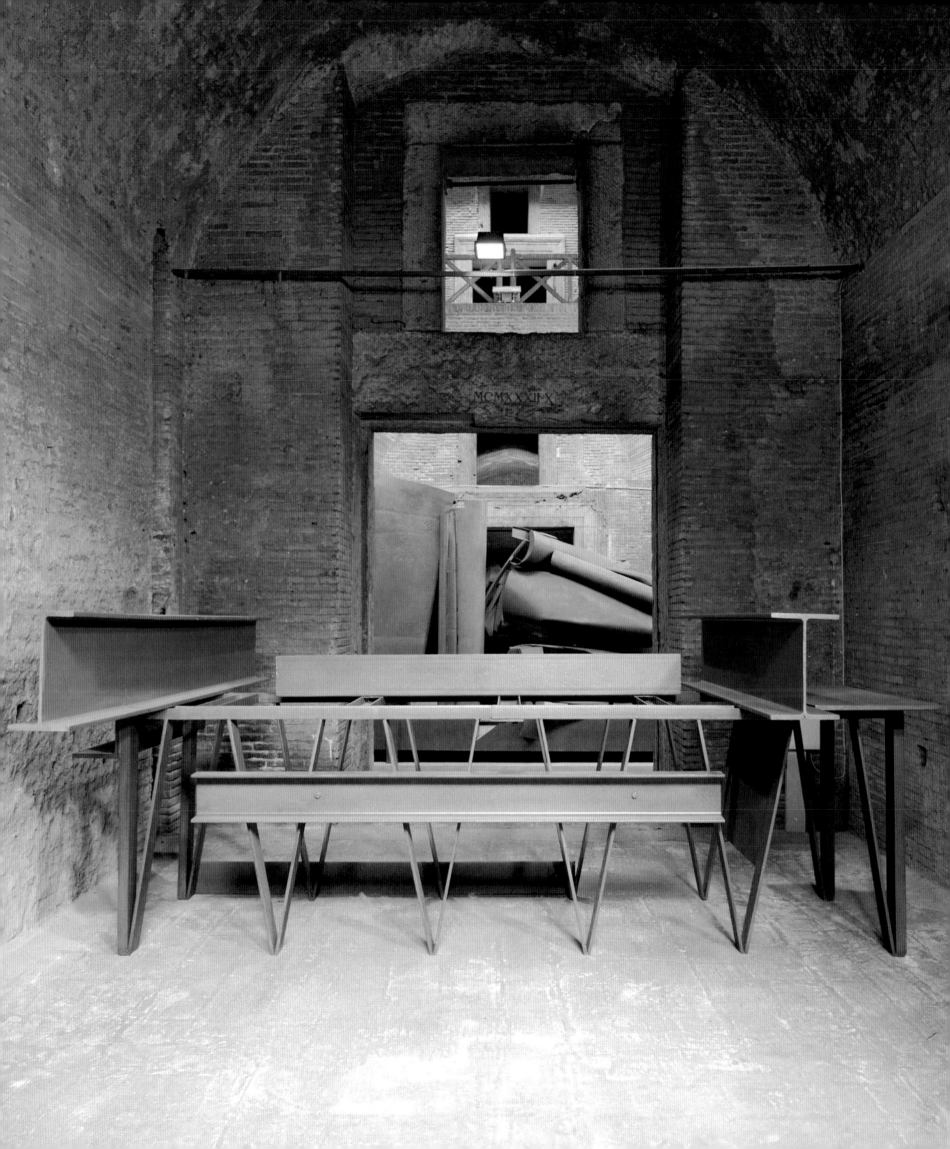

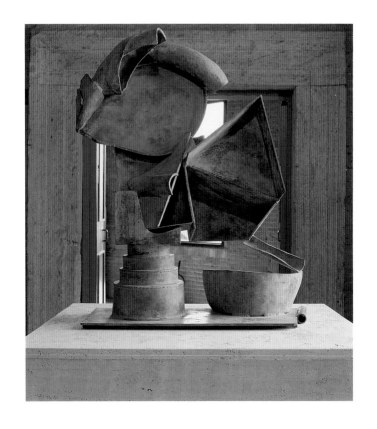

PLATE XLV

'RHENISH QUARTER' 1986-87

(32)

PLATE XLVI

'THE MOROCCANS' 1984-87

(29)

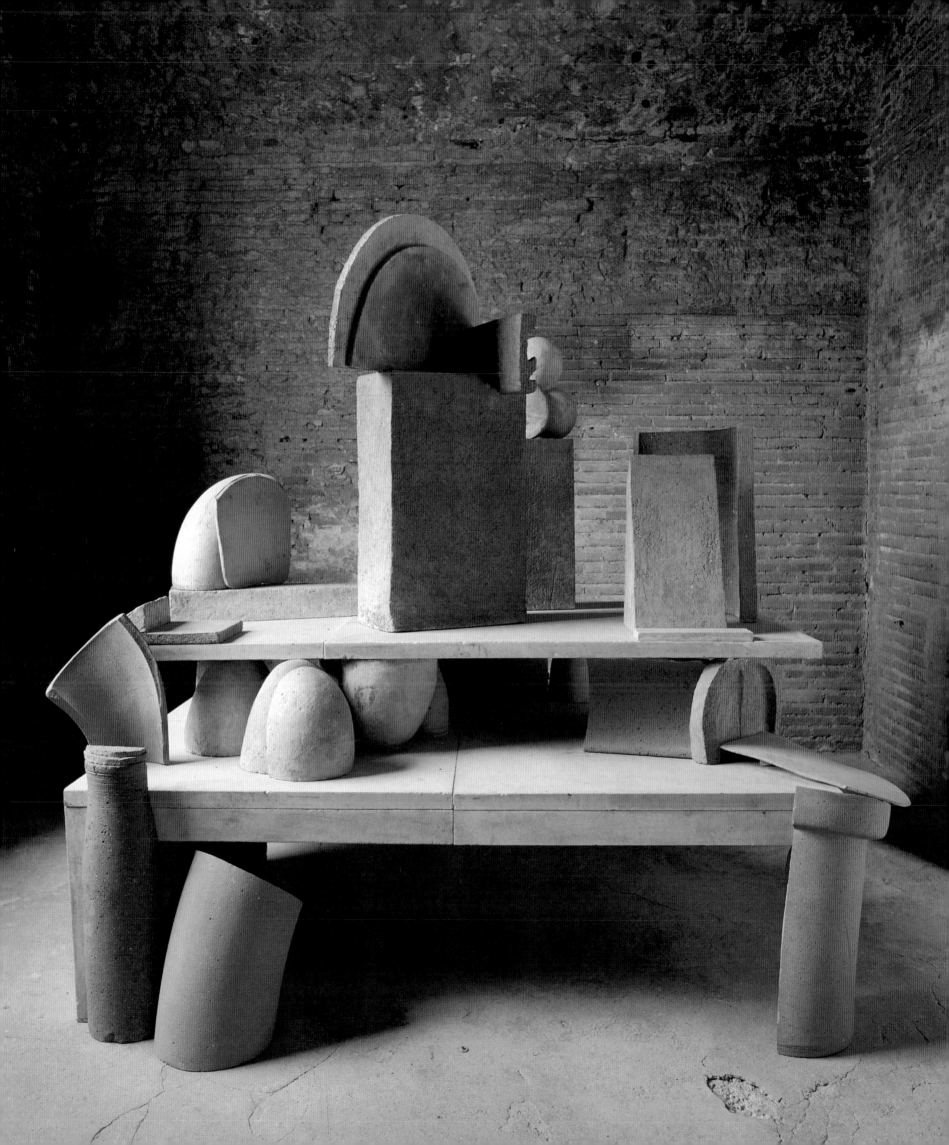

PLATE XLVII

'CHILD'S TOWER ROOM' 1983-84

(27)

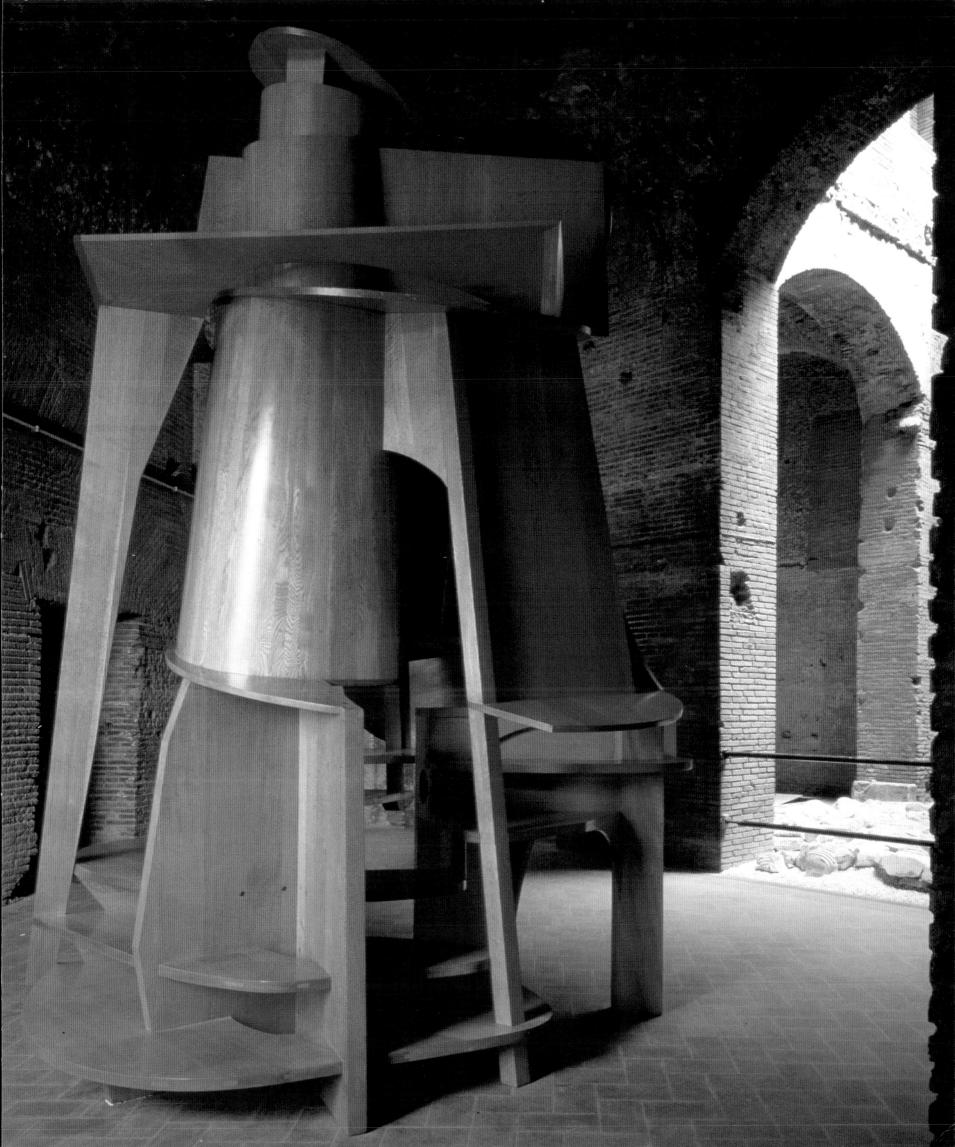

PLATE XLVIII

'TORONTO FLATS' 1974

(20)

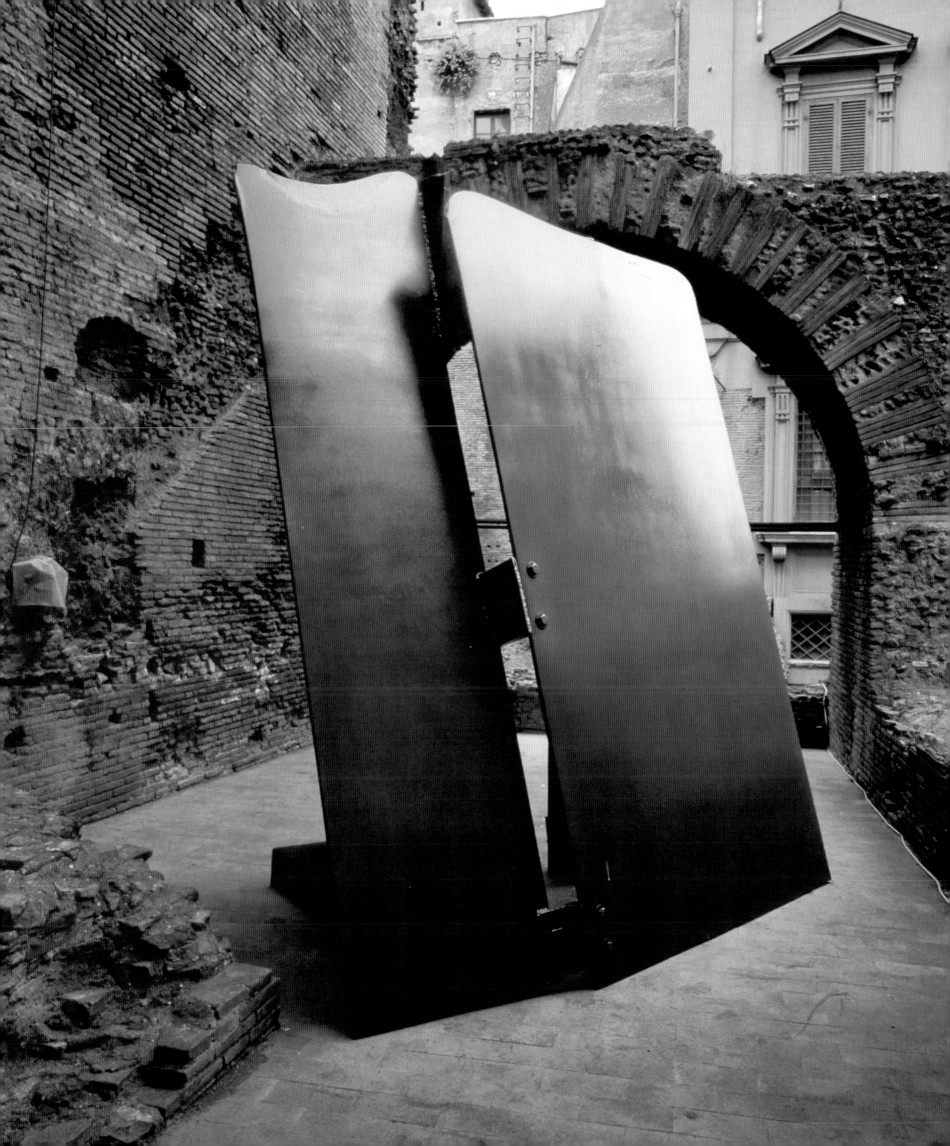

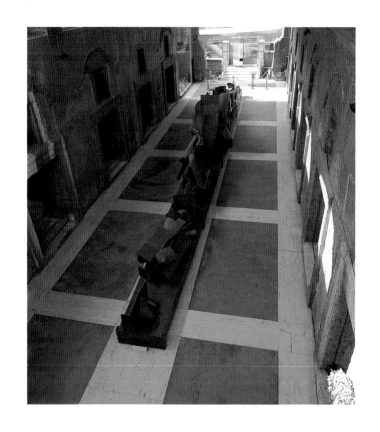

PLATE XLIX

'AFTER OLYMPIA' 1986-87
SEEN FROM THE UPPER ARCADE

(31)

PLATE L & LI (OVERLEAF)

'AFTER OLYMPIA' 1986-87
IN THE MAIN HALL OF THE TRAJAN
MARKETS LOOKING TOWARDS THE
ENTRANCE ON THE VIA QUATTRO
NOVEMBRE

(31)

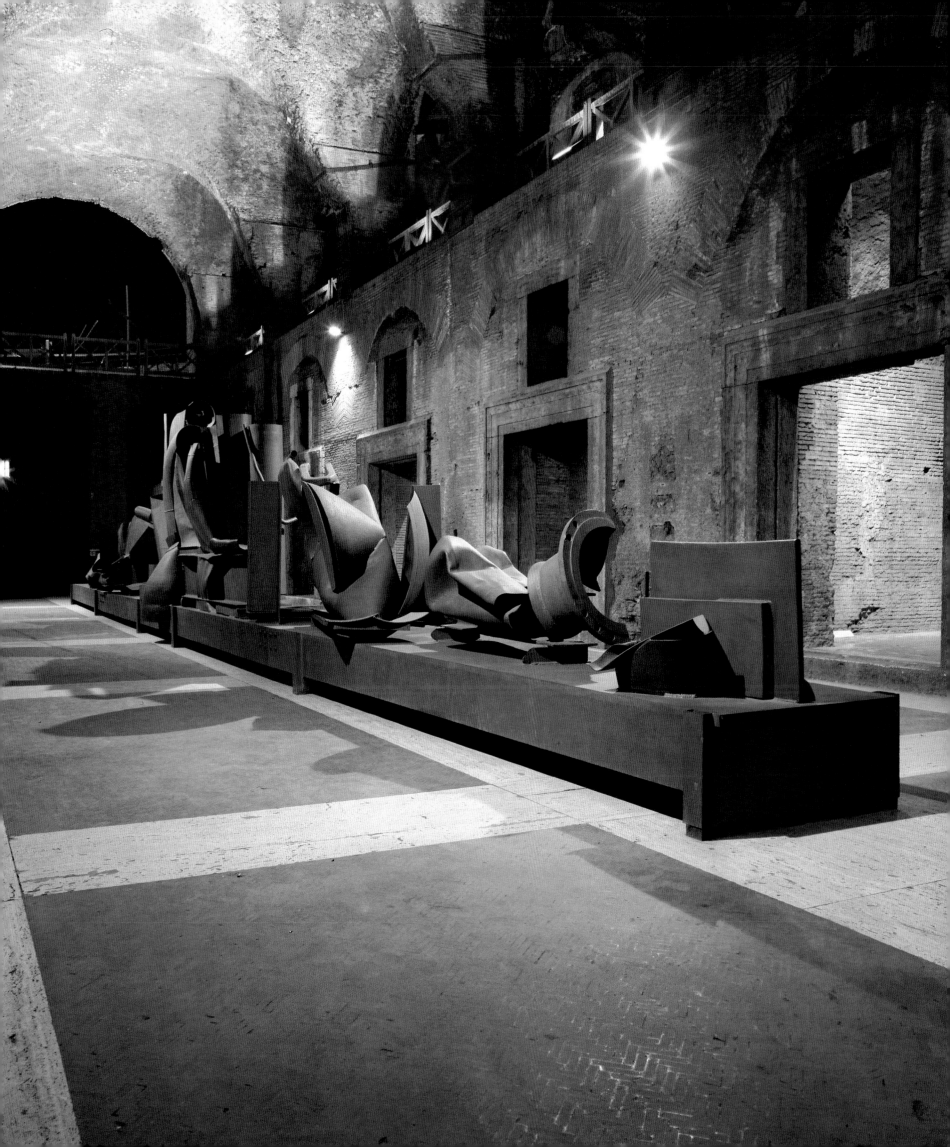

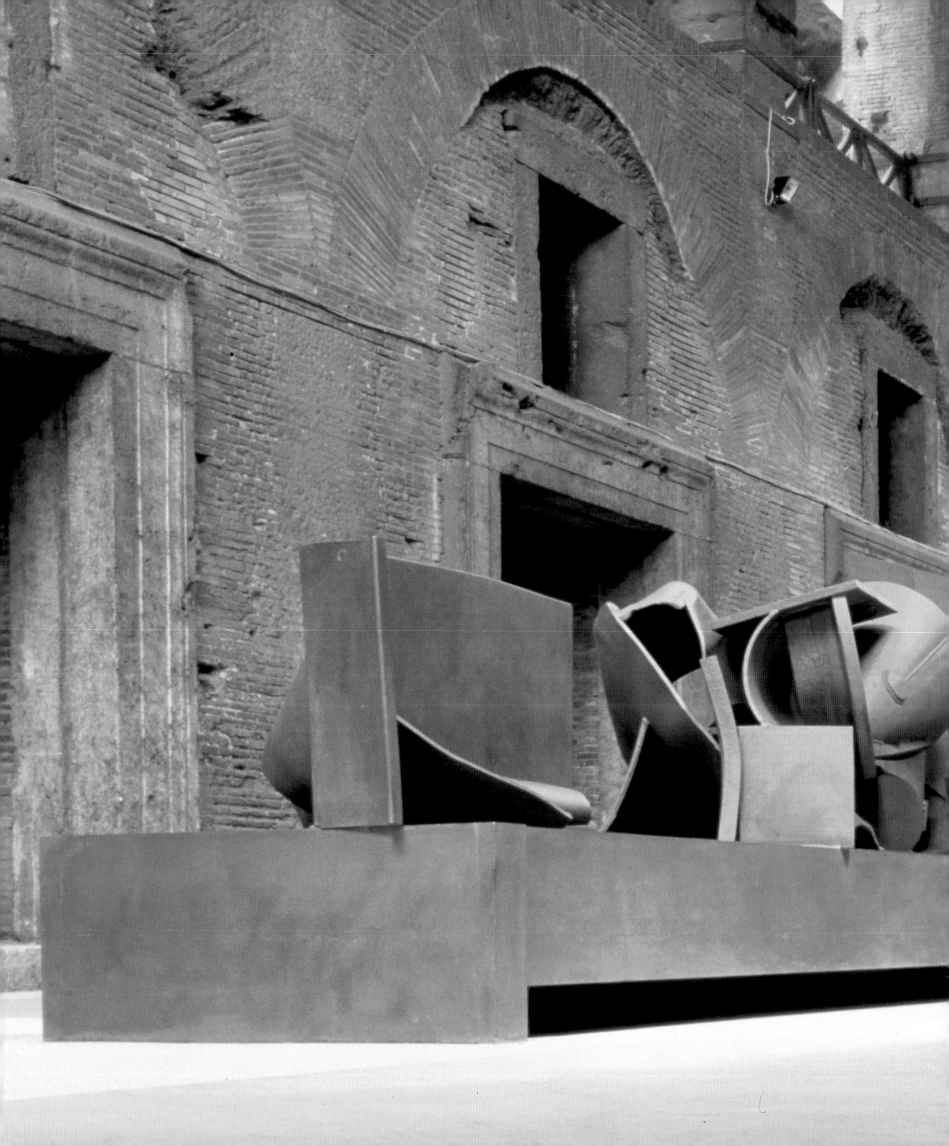

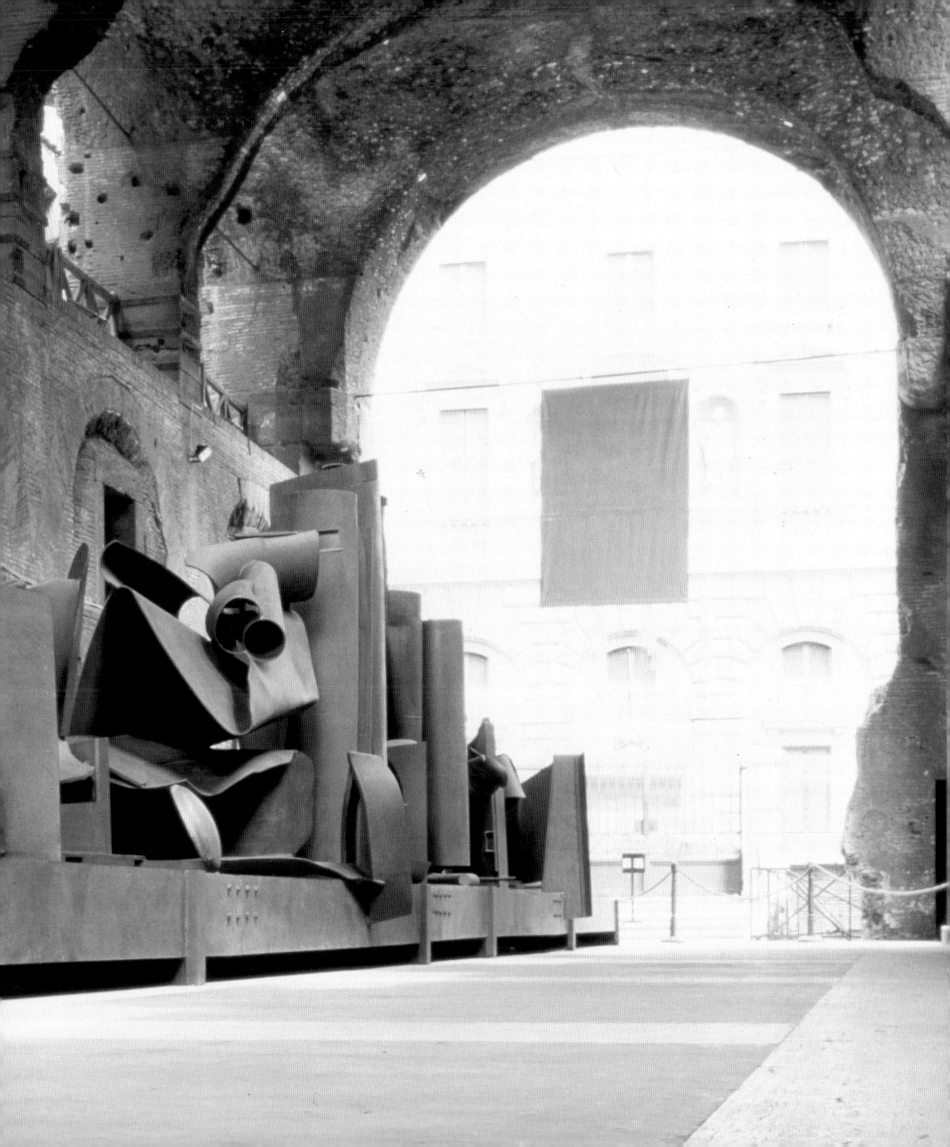

PLAN OF
THE TRAJAN
MARKETS

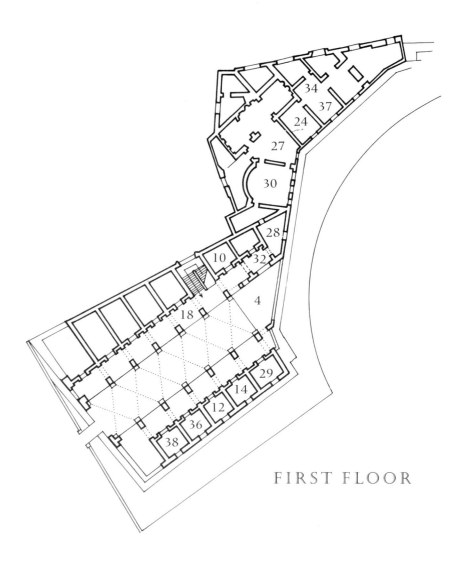

FIRST FLOOR

106

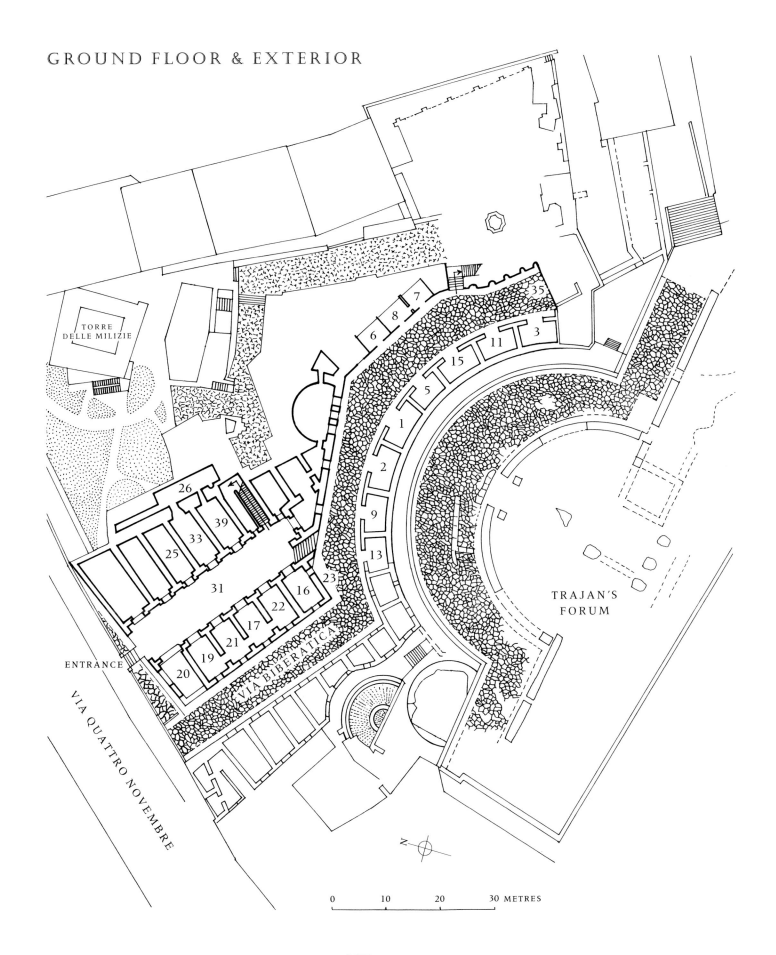

TORRE
DELLE MILIZIE

26

39

33

25

31

16

22

17

21

19

20

23

6

8 7

35

3

11

15

5

1

2

9

13

TRAJAN'S
FORUM

ENTRANCE

VIA BIBERATICA

VIA QUATTRO NOVEMBRE

N

0 10 20 30 METRES

107

SCULPTURES EXHIBITED AT THE TRAJAN MARKETS

ROME 1992

1

MIDDAY
1960
Steel painted yellow
240 x 96.5 x 366cm
94½ x 38 x 144ins
B822
The Museum of Modern Art
(Mr and Mrs Arthur Weisenburger
Fund, 1994), New York
PLATES VIII & IX

2

THE HORSE
1961
Steel painted dark brown
203.5 x 96.5 x 427cm
80 x 38 x 168ins
B823
Collection of Mr and Mrs David
Mirvish, Toronto
PLATE XVI

3

SCULPTURE SEVEN
1961
Steel painted green,
blue and brown
178 x 537 x 105.5cm
70 x 211½ x 41½ins
B825
Private Collection, London
PLATES X & XI

4

EARLY ONE MORNING
1962
Steel and aluminium painted red
290 x 620 x 333cm
114 x 244 x 131ins
B830
The Trustees of the Tate Gallery,
London
Presented by the Contemporary
Art Society
PLATES XXI, XXIII & XXIV

5

SCULPTURE TWO
1962
Steel painted green
208.5 x 361 x 259cm
82 x 142 x 102ins
B827
Collection of Mr and Mrs Donald
Gomme
PLATES XII, XIII & XV

6

MONTH OF MAY
1963
Steel and aluminium painted
magenta, orange and green
279.5 x 305 x 358.5cm
110 x 120 x 141ins
B833
Private Collection, London
PLATES XIV & XV

7

FIRST NATIONAL
1964
Steel painted green and yellow
139 x 287 x 297cm
55 x 113 x 117ins
B835
Private Collection, London
(not illustrated)

8

SHAFTSBURY
1965
Steel painted purple
68.6 x 323 x 274.5cm
27 x 127 x 108ins
B847
Private Collection, Harpswell, USA
PLATES XXXVII & XXXVIII

9

SPAN
1966
Steel painted burgundy
197 x 468 x 335.5cm
77 1/2 x 184 x 132ins
B898
Private Collection, Harpswell, USA
PLATES XVII & XVIII

10

CARRIAGE
1966
Steel painted blue
195.5 x 203.5 x 396.5 cm
77 x 80 x 156 ins
B894
Collection Patsy R. and Raymond D.
Nasher, Dallas (not illustrated)

11

PRAIRIE
1967
Steel painted matt yellow
96.5 x 582 x 320 cm
102 x 68 x 108 ins
B911
Collection of Lois and Georges
De Menil, USA (not illustrated)

12

TREFOIL
1968
Steel painted matt yellow
211 x 254 x 165 cm
83 x 100 x 65 ins
B920
Collection of Mr and Mrs David
Mirvish, Toronto (not illustrated)

13

ORANGERIE
1969
Steel painted red
225 x 162.5 x 231 cm
117 x 61 x 35 ins
B929
Collection of Kenneth Noland,
Salem, USA
PLATES XIX & XX

14

TABLE PIECE LXXXVIII
'DELUGE'
1969
Steel painted zinc chromate primer
101.6 x 60 x 96.5 cm
40 x 63 x 38 ins
B86
Gift of Guido Goldman in memory of
Minda de Gunzburg, 1985
The Museum of Modern Art,
New York
PLATE XLIII

15

SUN FEAST
1969-70
Steel painted yellow
181.5 x 416.5 x 218.5 cm
71¹/₂ x 164 x 86 ins
B933
Private Collection, Harpswell, USA
PLATES VI & VII

16

DEEP NORTH
1969-70
Steel and aluminium painted green
244 x 579 x 289.5 cm
96 x 228 x 114 ins
B935
Collection of Kenneth Noland,
Salem, USA
PLATE XXVIII

17

ORDNANCE
1971
Steel rusted and varnished
129.5 x 193 x 363 cm
51 x 76 x 143 ins
B995
Annely Juda Fine Art, London
PLATE XLIV

18

END GAME
1971-74
Steel rusted and varnished
161.5 x 442 x 119.5 cm
63¹/₂ x 174 x 47 ins
B1063
Collection of Mr and Mrs David
Mirvish, Toronto
PLATES XXV, XXVI & XXVII

19

VEDUGGIO SOUND
1972-73
Steel rusted and varnished
231 x 203 x 132 cm
91 x 80 x 52ins
B1037
Donation of Dr W.A. and
H.C. Bechtler
Kunsthaus, Zurich
PLATE XXIX

20

TORONTO FLATS
1974
Steel rusted and varnished
330 x 190.5 x 302 cm
130 x 75 x 119 ins
B1098
Annely Juda Fine Art, London
PLATE XLVIII

21

DURHAM PURSE
1973-74
Steel rusted and varnished
122 x 373.5 x 76 cm
48 x 147 x 30ins
B1051
Gift of Joanne F. Dupont,
Museum of Fine Arts, Boston
PLATE XXXIV

22

ROMAN
1970-76
Steel rusted and varnished
185.5 x 274.5 x 244 cm
73 x 108 x 96 ins
B976
Annely Juda Fine Art, London
PLATE XXXIII

23

MIDNIGHT GAP
1976-78
Steel rusted, varnished and painted
green
180.5 x 361 x 279 cm
71 x 142 x 110 ins
B1155
Private Collection, British Columbia,
Canada
PLATES XVIII, XXI & XXII

24

AFTER EMMA
1977-82
Steel rusted and varnished
244 x 274.5 x 188 cm
96 x 108 x 74 ins
B1606
Private Collection, London
(not illustrated)

25

THE SOLDIER'S TALE
1983
Steel patinated and painted
183 x 208 x 134.5 cm
72 x 82 x 53 ins
B1635
Private Collection, London
PLATE XL

26

ODALISQUE
1983-84
Steel varnished
195.5 x 246.5 x 162.5 cm
77 x 97 x 64 ins
B1768
Gift of Stephen and Nan Swid
Metropolitan Museum of Art,
New York
PLATE XXXIX & XLI

27

CHILD'S TOWER ROOM
1983-84
Wood – Japanese Oak, varnished
381 x 274.5 x 274.5 cm
150 x 108 x 108 ins
B1719
Annely Juda Fine Art, London
PLATE XLVII

28

TABLE PIECE Y-49
'AFTER PICASSO'
1985
Steel rusted and waxed
80 x 94 x 78.5 cm
31$^{1}/_{2}$ x 37 x 31 ins
B1673
Collection of Sherry Stuart
Christhils III, Baltimore
PLATE XXX

29

THE MOROCCANS
1984-87
Stoneware, earthenware
stainless steel support
183 x 203 x 172.5 cm
72 x 80 x 68 ins
B1860
Hakone Open Air Museum, Japan
PLATE XXV & XLVI

30

TABLE PIECE Y-92
'THE TRIUMPH OF CAESAR'
1987
Steel waxed
157.5 x 343 x 198 cm
62 x 135 x 78 ins
B1822
Private Collection, Harpswell, USA
PLATE XXXV

31

AFTER OLYMPIA
1986-87
Steel rusted, shot blasted
and varnished
332.5 x 2342 x 170 cm
131 x 922 x 67 ins
B1909
E.P.A.D., La Défense, Paris
PLATES XLIV, XLIX, L & LI

32

RHENISH QUARTER
1986-87
Bronze cast and welded, with brass
101.5 x 91.5 x 37 cm
40 x 36 x 14$\frac{1}{2}$ ins
B1870
Wakayama Prefectural Museum
of Modern Art, Wakayama
PLATE XLV

33

SUN GATE
1986-88
Steel rusted and varnished
231 x 292 x 91.5 cm
91 x 115 x 36 ins
B1914
Private Collection, London
PLATE XLII

34

MEDUSA
1989
Steel waxed
180.5 x 198 x 119.5 cm
71 x 78 x 47 ins
B2068
John Berggruen Gallery,
San Francisco
(not illustrated)

35

NORTH OF ROME
1989
Steel painted
232.5 x 259 x 355.5 cm
91$\frac{1}{2}$ x 102 x 140 ins
B2063
Collection of Mr and Mrs Yamaguchi,
Wakayama, Japan
PLATES IV & V & JACKET

36

TABLE PIECE
'LOOSE CHANGE'
Cascade Series
1990
Steel waxed
114.5 x 167.5 x 106.5 cm
45 x 66 x 42 ins
B1971
Private Collection, USA
PLATE XXXVI

37

TABLE PIECE
'CLEAR SIGHT'
Cascade Series
1989-90
Steel waxed
106.5 x 106.5 x 132 cm
42 x 42 x 52 ins
B1966
Annely Juda Fine Art, London
PLATE XXXII

38

FLOOR PIECE
'SUMMER TABLE'
Cascade Series
1990
Steel
120.5 x 211 x 106.5 cm
47$^{1}/_{2}$ x 83 x 42 ins
B1977
Annely Juda Fine Art, London
PLATE XXXI

39

NIGHT AND DREAMS
1990-1991
Steel waxed
104 x 224 x 188 cm
41 x 88 x 74 ins
André Emmerich Gallery, New York
PLATE XLI

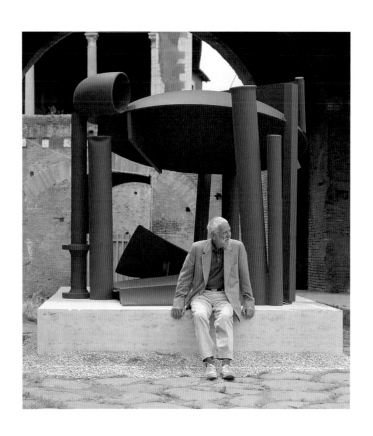

CHRONOLOGY

1924
Born 8 March, New Malden, Surrey

1937-42
Attends Charterhouse School,
Godalming, Surrey
During vacations works in studio of the
sculptor Charles Wheeler

1942-44
Attends Christ's College, Cambridge:
M.A. in engineering
During vacations attends Farnham School
of Art

1944-46
Fleet Air Arm of Royal Navy

1946-47
Regent Street Polytechnic, London
Studies sculpture under Geoffrey Deeley

1947-52
Royal Academy Schools, London

1948
Awarded two silver medals and one
bronze from the Royal Academy Schools
for clay figure models, carving and com-
position

1949
Marries the painter Sheila Girling
(two sons: Timothy (1951) and Paul
(1958))

1951-53
Works as part-time assistant to Henry
Moore

1953-79
Teaches part-time at St Martin's School of
Art, London

1954
Moves to Hampstead; models figurative
sculpture in clay and plaster

1955
Included in group exhibition of sculpture
at *New Painters and Painter-Sculptors,*
Institute of Contemporary Arts, London

1956
First one-man exhibition: Galleria del
Naviglio, Milan

1957
First one-man show in London: Gimpel
Fils Gallery

1959
Wins sculpture prize at first Paris
Biennale
Tate Gallery purchases *Woman Waking Up,*
1955
Meets Clement Greenberg in London
Visits USA for the first time on Ford
Foundation-English Speaking Union
Grant: meets Kenneth Noland and David
Smith, also Robert Motherwell, Helen
Frankenthaler and others

1960
Returns to London; makes first abstract
sculptures in steel including *Twenty-Four
Hours,* 1960 (B819)(Tate Gallery)
Visits Carnac, Brittany, studies the
primitive *menhirs* and *dolmens*

1961
First exhibits a steel sculpture *The Horse,*
1961 (B823) in *New London Situation.*
Marlborough New London Gallery,
London
First polychrome sculpture, *Sculpture
Seven,* 1961 (B825)

1963
One-man exhibition of abstract steel sculptures at the Whitechapel Gallery, London

1963-65
Teaches at Bennington College, Bennington, Vermont
Renews contact with Noland and Smith

1964
First one-man exhibition in New York: André Emmerich Gallery

1965
Early One Morning, 1962 (B830) in *British Sculpture in the Sixties*, Tate Gallery, London

1966
Exhibits as one of *Five Young British Artists*, British Pavilion, Venice Biennale (with painters Richard Smith, Harold Cohen, Bernard Cohen and Robyn Denny)
Begins first table sculptures

1967
Retrospective exhibition at Rijksmuseum Kröller-Müller, Otterlo
Acquires stock of raw materials from the estate of David Smith

1968
Exhibits *Titan*, 1964 (B840), in *Noland, Louis and Caro*, Metropolitan Museum of Art, New York

1969
Retrospective exhibition at Hayward Gallery, London
Appointed Commander of the Order of the British Empire

Exhibits, with John Hoyland, in the British Section of X São Paulo Biennale
Pat Cunningham becomes Caro's assistant in the London studio

1970
Begins making unpainted steel sculptures

1971
Travels to Mexico, New Zealand, Australia and India

1972
Makes fourteen large sculptures using roll end steel at the Ripamonte factory, Veduggio, Italy. Returns the following May and September to complete them

1973
One-man exhibition at Norfolk and Norwich Triennial Festival, East Anglia
Museum of Modern Art, New York acquires *Midday*, 1960 (B822)

1974
Works at York Steel Co. Toronto and makes thirty-seven sculptures, assisted by sculptors James Wolfe and Willard Beopple

1975
Retrospective exhibition at Museum of Modern Art, New York (which later travels to Walker Art Center, Minneapolis; Museum of Fine Art, Houston and Museum of Fine Arts, Boston)
Works with clay at Ceramic Workshop at Syracuse University, New York, organised by Margie Hughto
Begins making sculptures in welded bronze

1976
Presented with Key to the City of New York by Mayor Abraham Beame

1977
Exhibition of table sculptures travels to Tel Aviv Museum and later tours Australia, New Zealand and Germany
Artist in residence at Emma Lake summer workshop, University of Saskatchewan

1978
Makes first 'writing pieces': calligraphic sculptures in steel
Executes commission for East Wing of the National Gallery in Washington, D.C.

1979
Receives Honorary Doctorates from East Anglia University and York University, Toronto
Made Honorary Member of American Academy and Institute of Arts and Letters, New York

1980
Makes first sculptures in lead and wood

1981
Makes wall reliefs in handmade paper, with Ken Tyler in New York
Exhibits at Städtische Galerie in Stadel, Frankfurt
Made Honorary Fellow, Christ's College, Cambridge
Receives Honorary Degree, Brandeis University, Massachusetts

1982
Appointed Trustee of Tate Gallery London
Initiates Triangle annual summer workshops for sculptors and painters at Pine Plains, New York: held annually thereafter

Joins Council of Slade School of Art

1984
One-man exhibition at Serpentine Gallery, London which travels to Copenhagen, Düsseldorf and Barcelona
Creates first sculpture with an architectural dimension: *Child's Tower Room* (B1719), an Arts Council commission, for *Four Rooms* exhibition at Liberty's London

1985
Visits Greece for the first time
Exhibits at Noorkipings Kunstmuseum, Sweden
Leads Sculptors' Workshop, Maastricht, Holland
Receives D.Litt., Cambridge University
Jon Isherwood becomes Caro's USA Studio assistant at Ancram, New York

1986
Completes work on *Scamander* (B1806) and *Rape of the Sabines* (B1807), first sculptures inspired by the pediments of Greek temples
Made Honorary Fellow, Royal College of Art

1987
Awarded knighthood, Queen's Birthday Honours
Executes *After Olympia* (B1909), his largest sculpture to date
Attends workshops in Berlin and Barcelona
Receives Honorary Degree, Surrey University

1988
Concludes investigations of pediment-inspired works with *Xanadu* (B1915)

1989
Exhibits at Walker Hill Art Center, Seoul
Sculpture workshop, Edmonton where
North of Rome (B2063) is created
Visits Korea and India
Receives Honorary Degree, Yale
University

1990
Completes work on *Night Movements*
(B2072), a single work in four separate
units
Retrospective exhibition at Musée des
Beaux Arts, Calais
Visits Japan and starts series of paper
reliefs at Nagatani's workshop, Obama

1991
Two important sculptures involving the
dialogue with architecture completed: *Sea
Music* for the quayside, Poole, Dorset, and
Octagon Tower-Tower of Discovery for
Sculpture towards Architecture,
an exhibition of recent work at the Tate
Gallery, London
Exhibits *The Cascades, Table Pieces*, at
Annely Juda Fine Art, London and André
Emmerich Gallery, New York
Awarded First Nobutaka Shikanai Prize,
Hakone Open Air Museum in Japan

1992
Exhibits thirty-nine sculptures, from
Midday to *After Olympia*, in Trajan
Markets, Rome
Made Honorary Member, Accademia di
Belle Arte di Brera
Receives Praemium Imperiale award for
sculpture, Tokyo

1993
Receives Honorary Degree, Winchester
School of Art

ACKNOWLEDGMENTS

The exhibition of Anthony Caro's
sculpture at the Trajan Markets in Rome
owes its origin and inspiration to
Professor Giovanni Carandente, who was
an early admirer of Caro's work. While the
exhibition was very much the personal
creation of Anthony Caro and Giovanni
Carandente, many different organisations
and individuals were involved with its
realisation. Without their generosity,
hard work and enthusiasm the exhibition
could not have been achieved.